PRESENCE

THE INVISIBLE PORTRAIT

PRESENCE
THE INVISIBLE PORTRAIT

CHRIS BUCK

KEHRER

ISBN 978-3-86828-307-5

Book design by Stephen Gates (www.stephengates.com)

Kehrer Heidelberg Berlin
www.kehrerverlag.com

FOREWORD
BY RODNEY ROTHMAN

It's not easy to convince fifty public figures to pose for a photograph in which they will not technically appear.

Public figures are not conceptual people. They are busy and suspicious, vulnerable, result-oriented. They're being pulled in multiple directions at once before you even hit them with your own request. Like I said, it's not easy. You have to be willing to beg, wheedle, horse-trade, appeal to reason, appeal to duty, annoy, pester, hassle, outsmart, play dumb, lie outright. Chris Buck did all these things, but mainly he pestered.

I was in New York City producing the movie *Get Him to the Greek*. I'm an old friend of Chris through his wife, Michelle. He had some favors to call in. I remember feeling mildly put out when Chris decided to cash a favor in by asking me if he could come by our set during a lunch break to take pictures of one of the stars of our movie. That meant I would have to pull him out of his only real break in a sixteen-hour workday to do exactly what he had just spent his entire morning doing—having his picture taken. And in this case, he wouldn't even be visible in the picture, which sort of defeats the point.

It was with some dread that I walked into Russell Brand's trailer and asked if he'd mind participating in Chris's project. I got ready to have to explain it all multiple times.

But instead of letting loose a stream of florid Dickensian profanity, Russell reacted with delight. Chris's idea struck him as subversive. He wanted to participate. In fact he was so enthusiastic that I pretended that arranging the thing had been my idea.

Russell spent the better part of lunchtime working with Chris. He hid in plain sight all around the lobbies of the Plaza Hotel. The result ended up on the cover of this collection. Russell is a vivid presence in real life as well as in front of the camera. He makes a strong impression. So too, in Chris's photograph of Russell, which suggests that even the void Russell leaves behind is larger than life.

It isn't surprising to me that so many celebrities took to Chris's concept and agreed to "pose" for him. Most actors are accustomed to being used as a prop. They sit where they're told and act how they're supposed to for the director, or the photographer. They're under hot lights, dressed in borrowed clothing. Most of the time the camera captures their reflection—that is all. Nobody understands this more than Chris who has taken thousands of photographs of celebrities for magazines and advertisements. Perhaps that's what fueled his desire to see this project through, amidst the pestering and cajoling and calling in favors—to strip the artifice away as much as possible.

The result is *Presence*, a series comprising what may be his most truthful portraits. Or, if not that, then they may be his least false. Or, maybe they're total bullshit. The answer is fixed somewhere inside the photographs, without a doubt, though we can't see it.

I, _____Fi Campbell Johnson_____, can testify to observing and

being attendant for Chris Buck's "Presence" photo session

with _____**SETH ROGEN**_____. And can vouch for the

subject's being within the photographer's frame despite not

being visible.

Witness signature

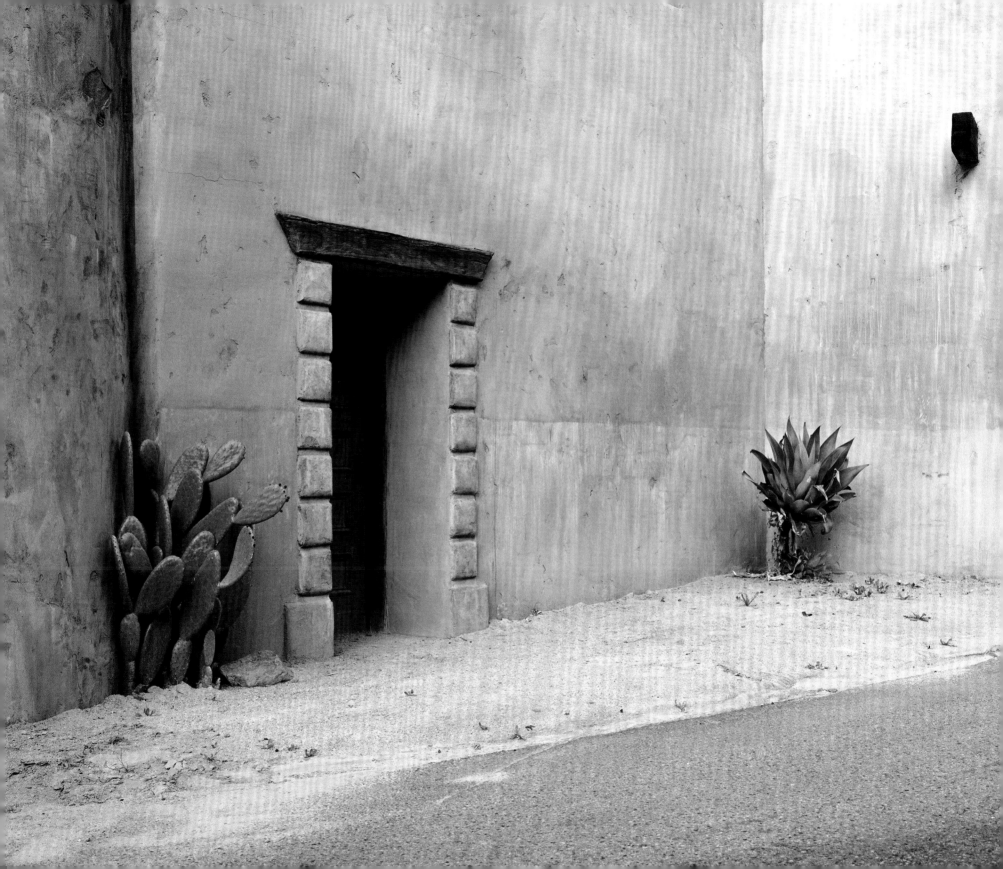

I, _____CHUCK CLOSE_____, can testify to observing and

being attendant for Chris Buck's "Presence" photo session

with _____**CHUCK CLOSE**_____. And can vouch for the

subject's being within the photographer's frame despite not

being visible.

Witness signature

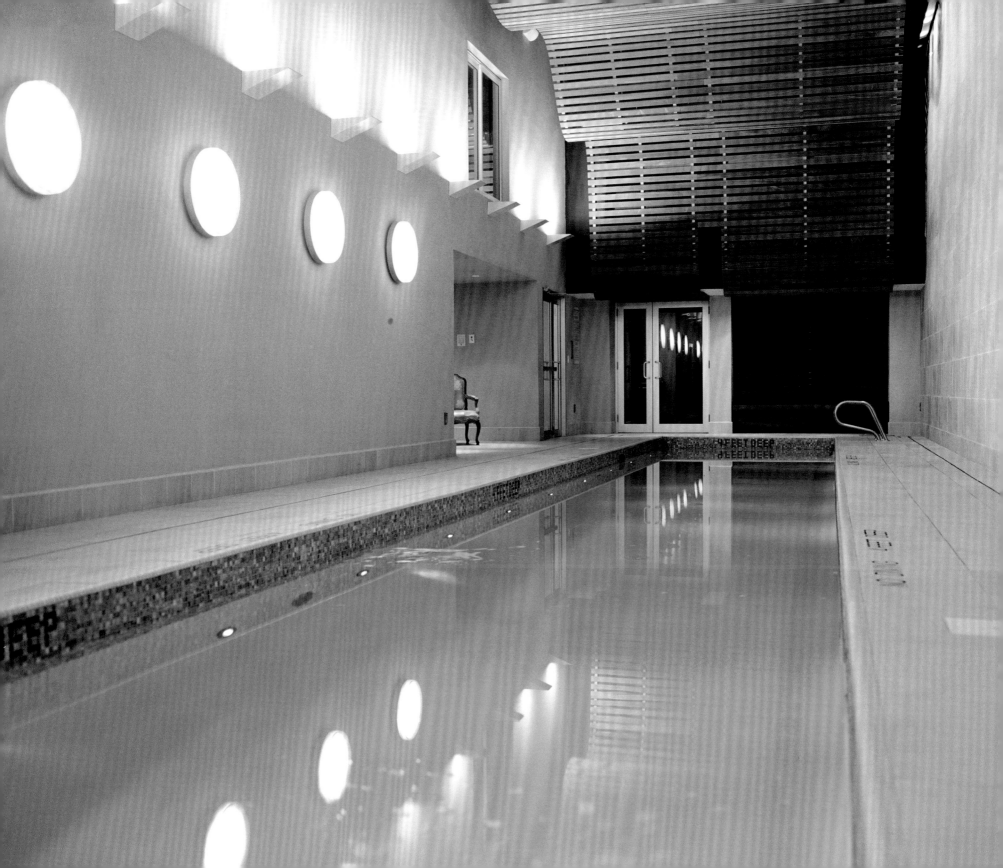

I, _____DANIELLE SPENCER_____, can testify to observing and

being attendant for Chris Buck's "Presence" photo session

with _____DAVID BYRNE_____. And can vouch for the

subject's being within the photographer's frame despite not

being visible.

Witness signature

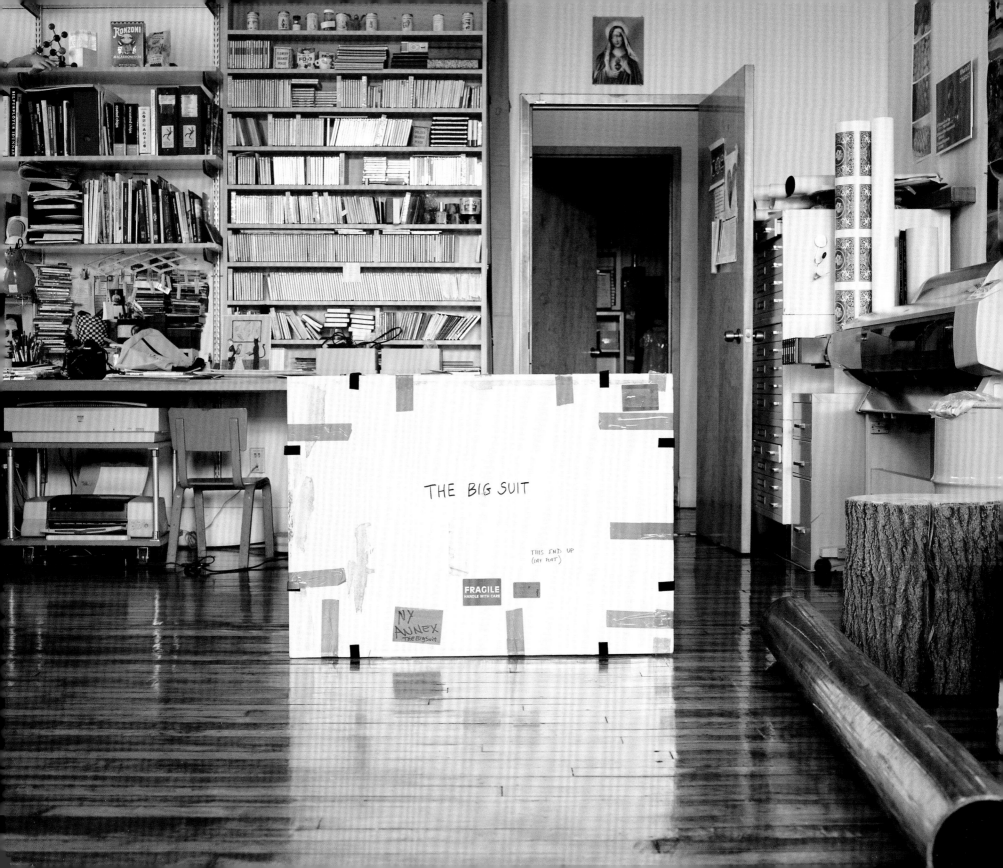

I, _____Michael Kochman_____, can testify to observing and

being attendant for Chris Buck's "Presence" photo session

with _____DAVID LYNCH_____. And can vouch for the

subject's being within the photographer's frame despite not

being visible.

Witness signature

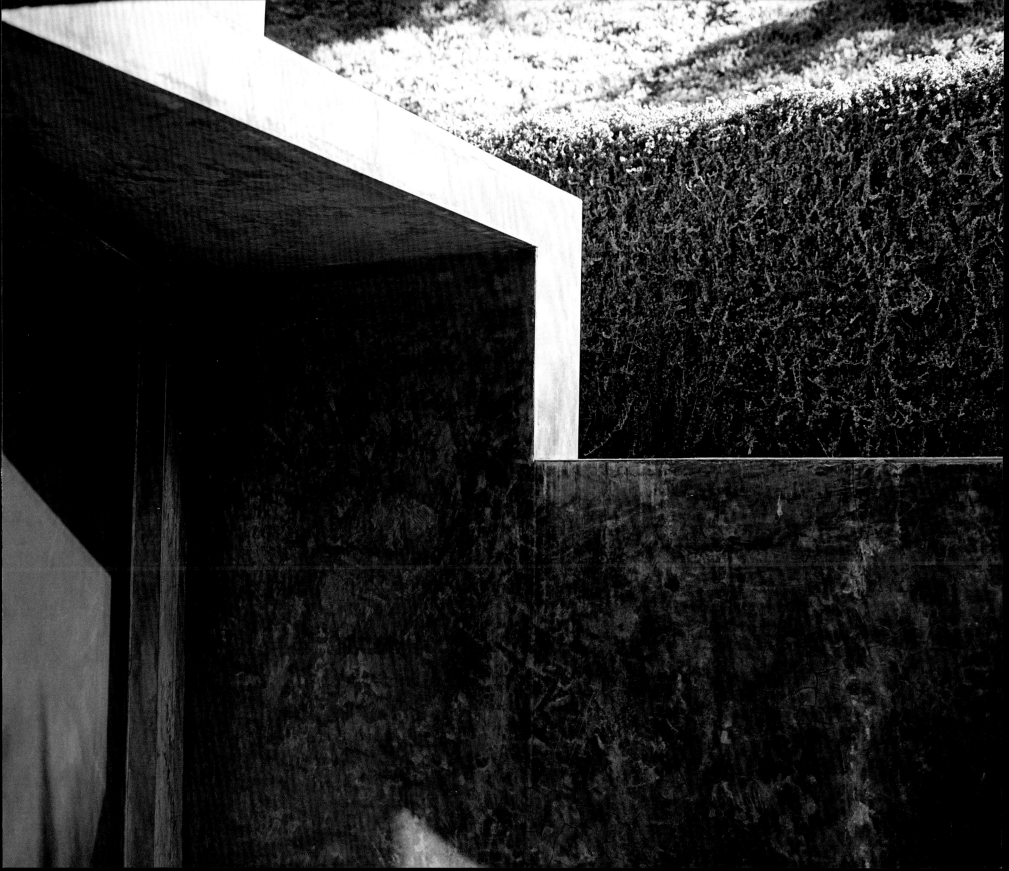

I, _____KAYLEEN MCADAMS._____, can testify to observing and

being attendant for Chris Buck's "Presence" photo session

with _____AMY POEHLER_____. And can vouch for the

subject's being within the photographer's frame despite not

being visible.

Witness signature

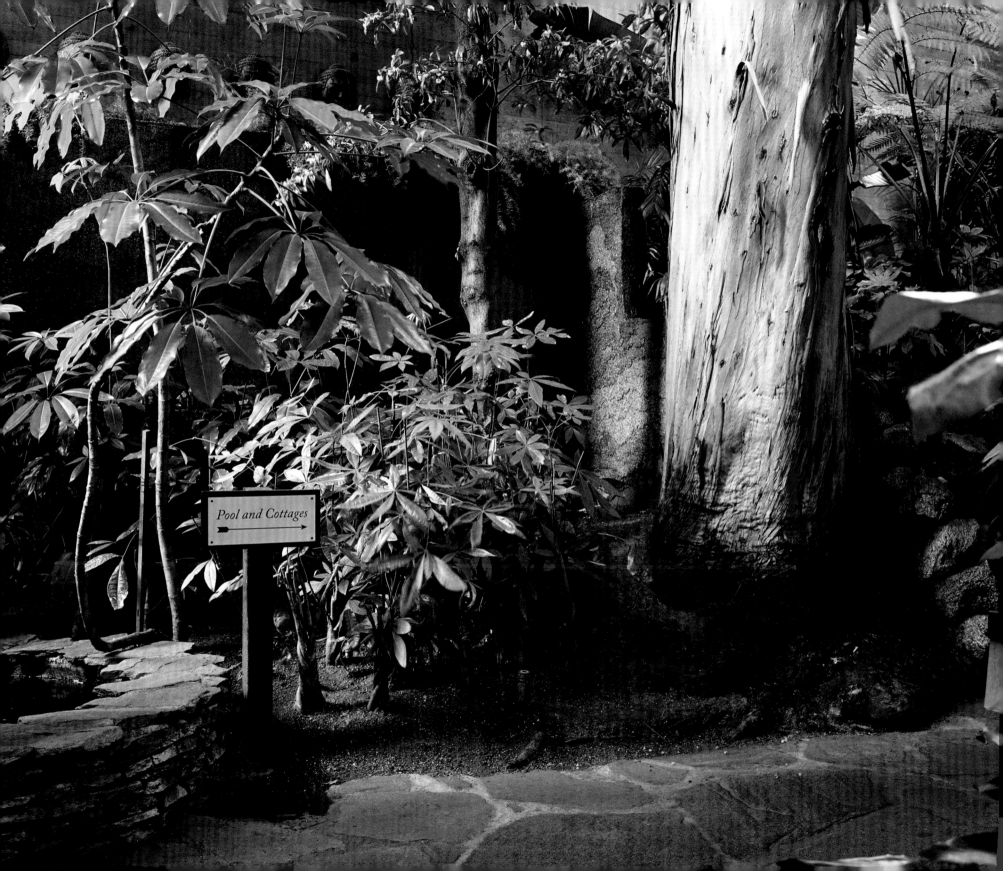

I, _____Crystal Petro_____, can testify to observing and

being attendant for Chris Buck's "Presence" photo session

with _____**CINDY SHERMAN**_____. And can vouch for the

subject's being within the photographer's frame despite not

being visible.

Crystal Petro
Witness signature

I, _____Whitney Tancred_____, can testify to observing and

being attendant for Chris Buck's "Presence" photo session

with _____**KATHY GRIFFIN**_____. And can vouch for the

subject's being within the photographer's frame despite not

being visible.

Witness signature

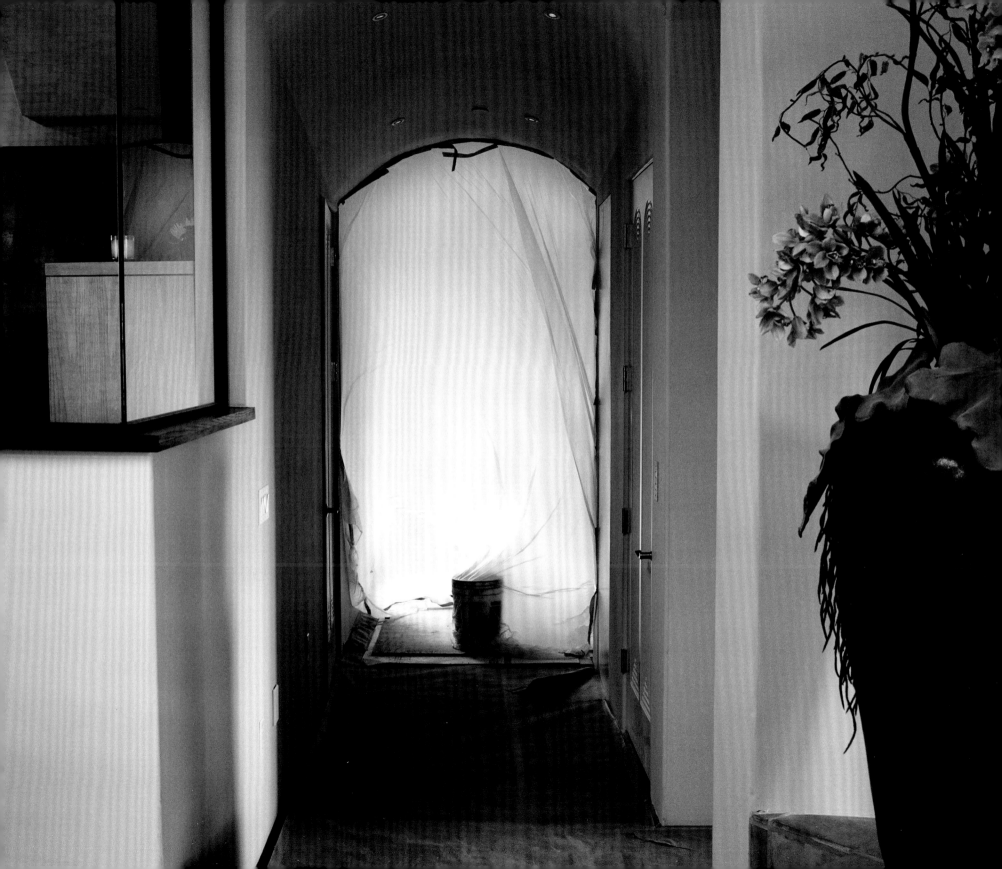

I, _____TIM DAVIN_____, can testify to observing and

being attendant for Chris Buck's "Presence" photo session

with _____PAUL ANKA_____. And can vouch for the

subject's being within the photographer's frame despite not

being visible.

Witness signature

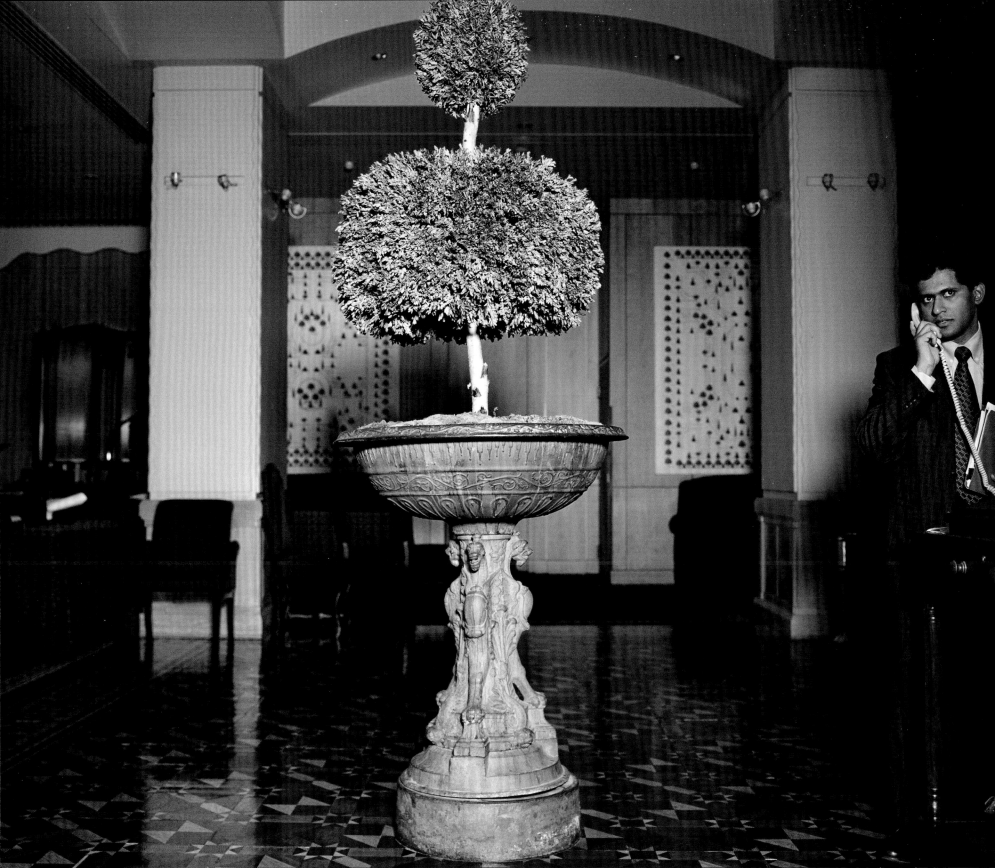

I, _____ Matt Hoover _____, can testify to observing and

being attendant for Chris Buck's "Presence" photo session

with _____ JAY LENO _____. And can vouch for the

subject's being within the photographer's frame despite not

being visible.

Witness signature

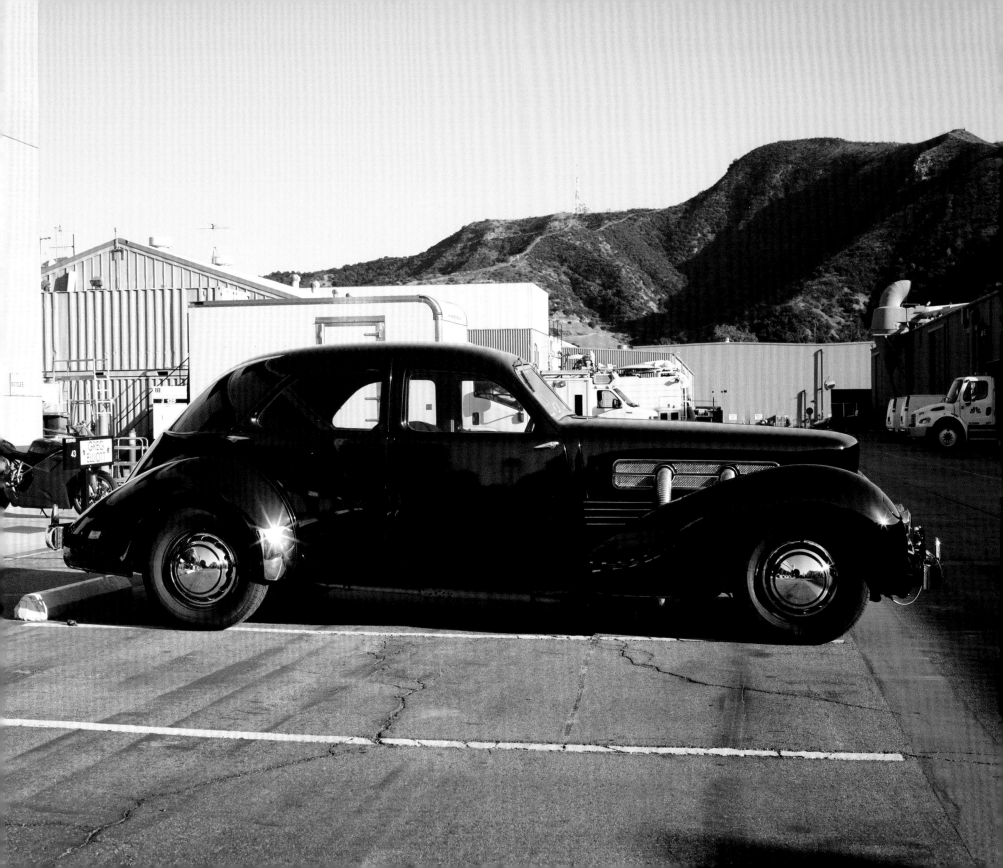

I, _____Marisa Berard_____, can testify to observing and

being attendant for Chris Buck's "Presence" photo session

with _____MICHAEL STIPE_____. And can vouch for the

subject's being within the photographer's frame despite not

being visible.

_Marisa S Berard_____
Witness signature

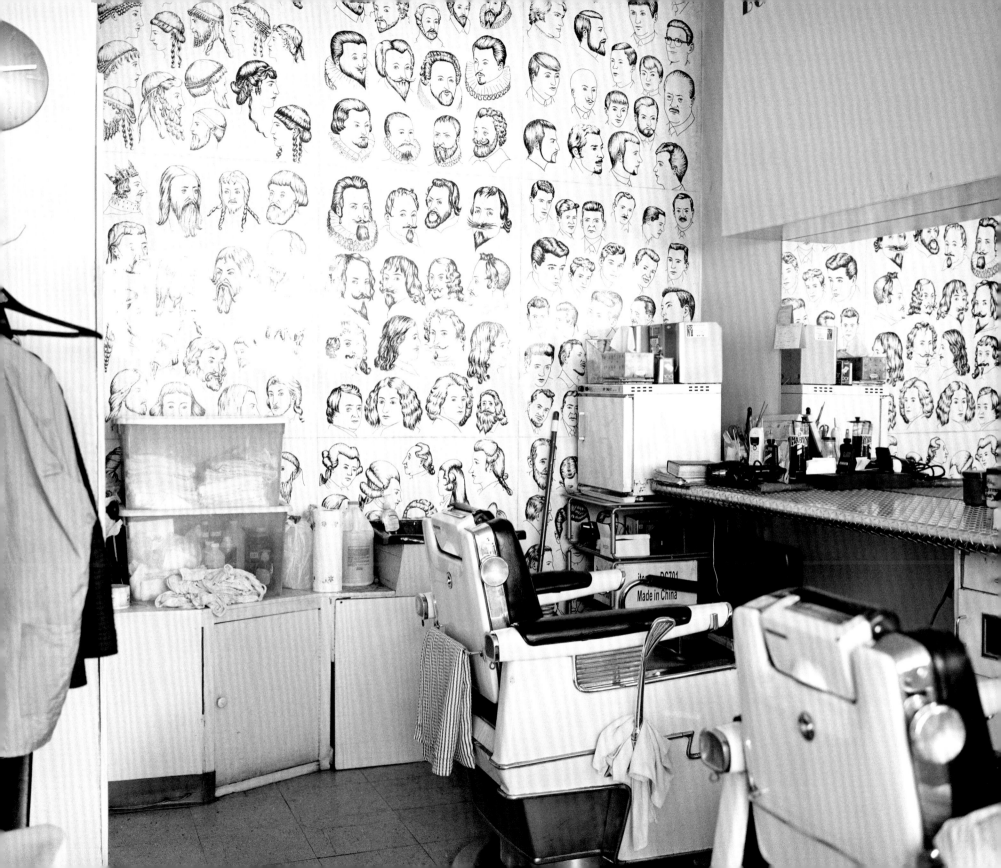

I, _____STUART GOW_____, can testify to observing and

being attendant for Chris Buck's "Presence" photo session

with _____WILLIAM SHATNER_____. And can vouch for the

subject's being within the photographer's frame despite not

being visible.

Witness signature

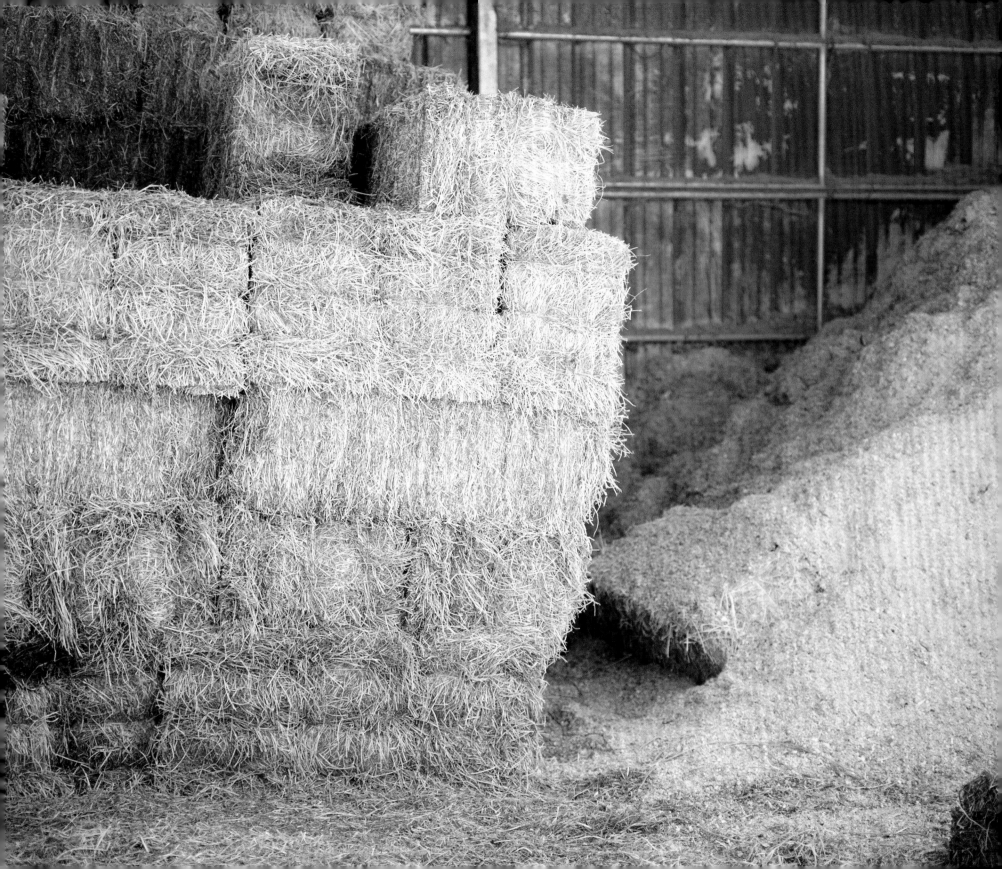

I, _____, can testify to observing and

being attendant for Chris Buck's "Presence" photo session

with _____ DAVE MATTHEWS _____. And can vouch for the

subject's being within the photographer's frame despite not

being visible.

Witness signature

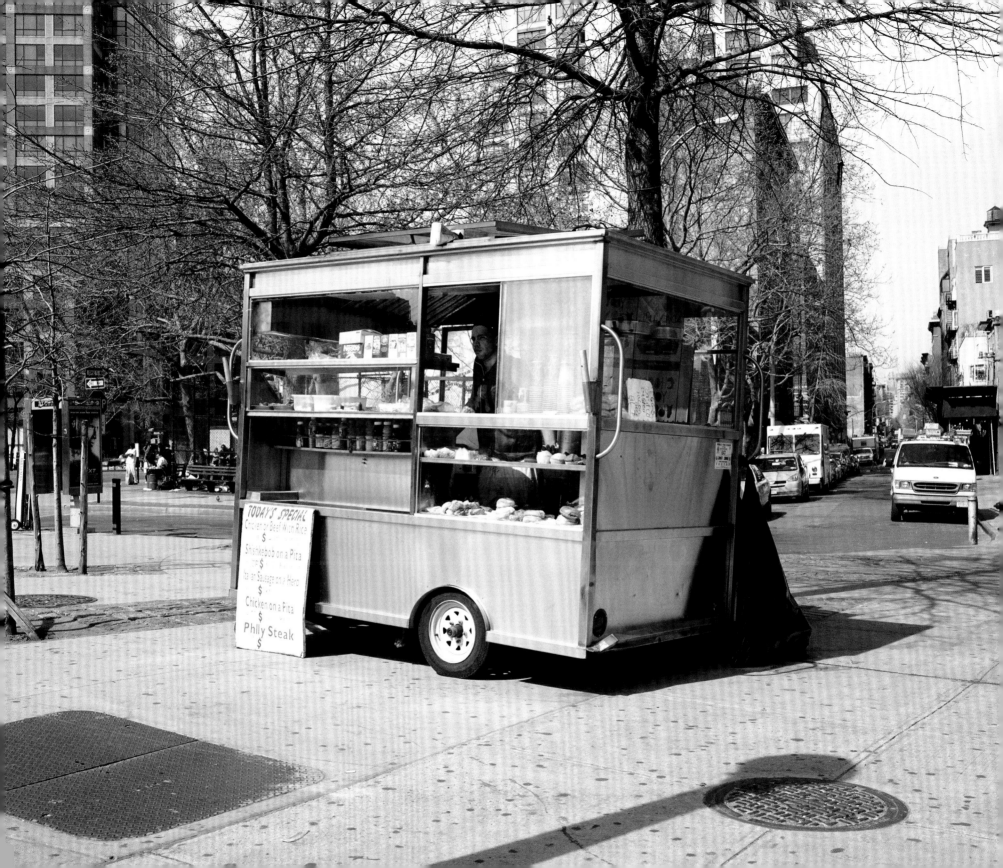

TODAY'S SPECIAL
Chicken or Beef With Rice
$
Shishkebob on a Pita
$
Italian Sausage on a Hero
$
Chicken on a Pita
$
Philly Steak
$

I, _____ JOE TOMCHO _____, can testify to observing and

being attendant for Chris Buck's "Presence" photo session

with _____ ANTHONY BOURDAIN _____. And can vouch for the

subject's being within the photographer's frame despite not

being visible.

Witness signature

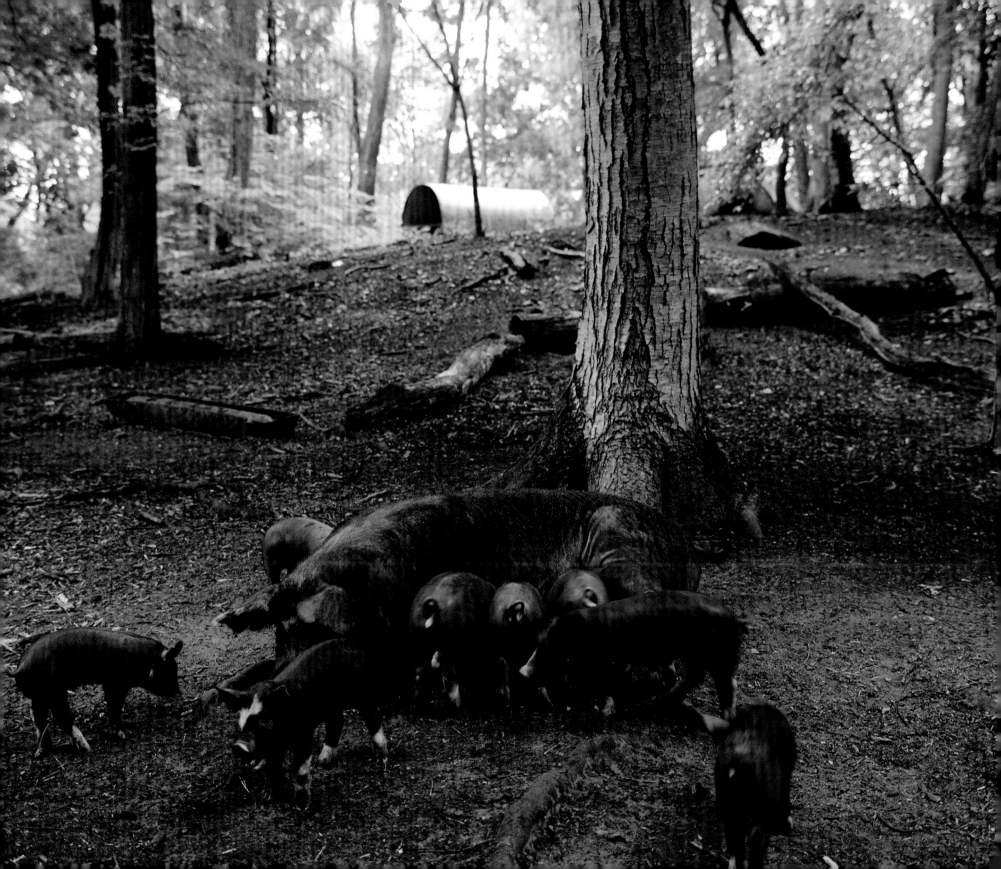

I, _____Guillermo del Toro_____, can testify to observing and

being attendant for Chris Buck's "Presence" photo session

with _____GUILLERMO DEL TORO_____. And can vouch for the

subject's being within the photographer's frame despite not

being visible.

Witness signature

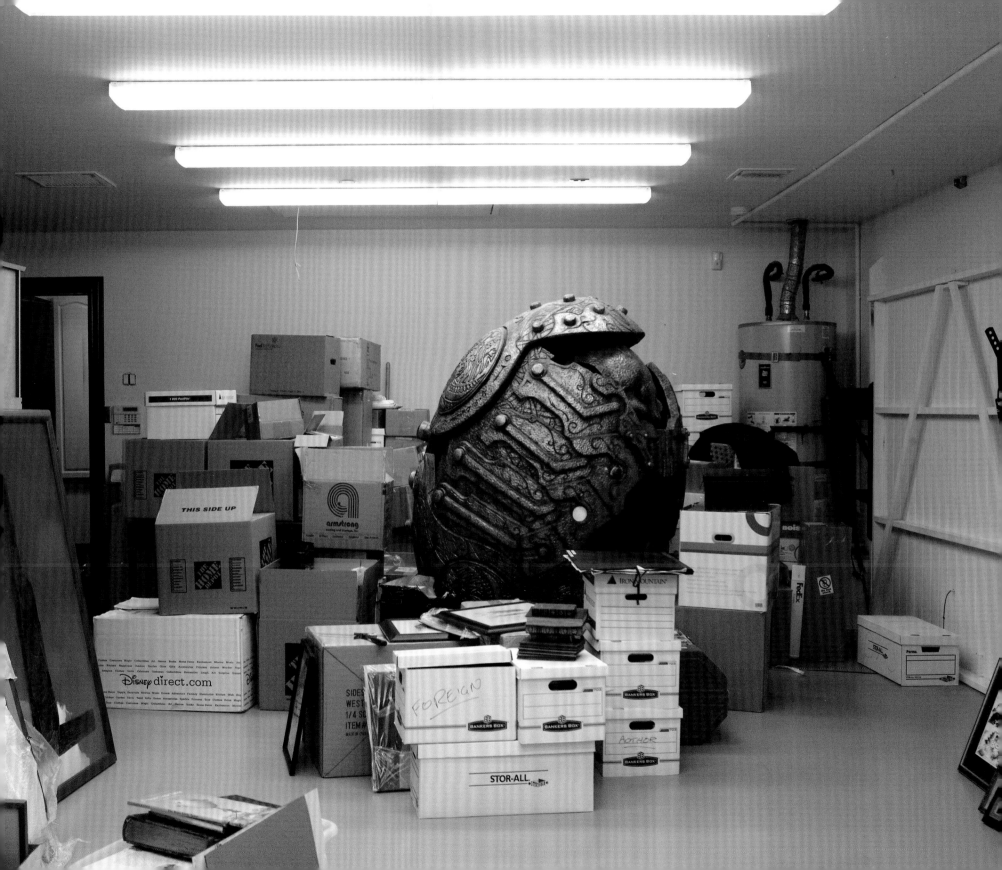

I, _____Hilary Hansen_____, can testify to observing and

being attendant for Chris Buck's "Presence" photo session

with _____AZIZ ANSARI_____. And can vouch for the

subject's being within the photographer's frame despite not

being visible.

Witness signature

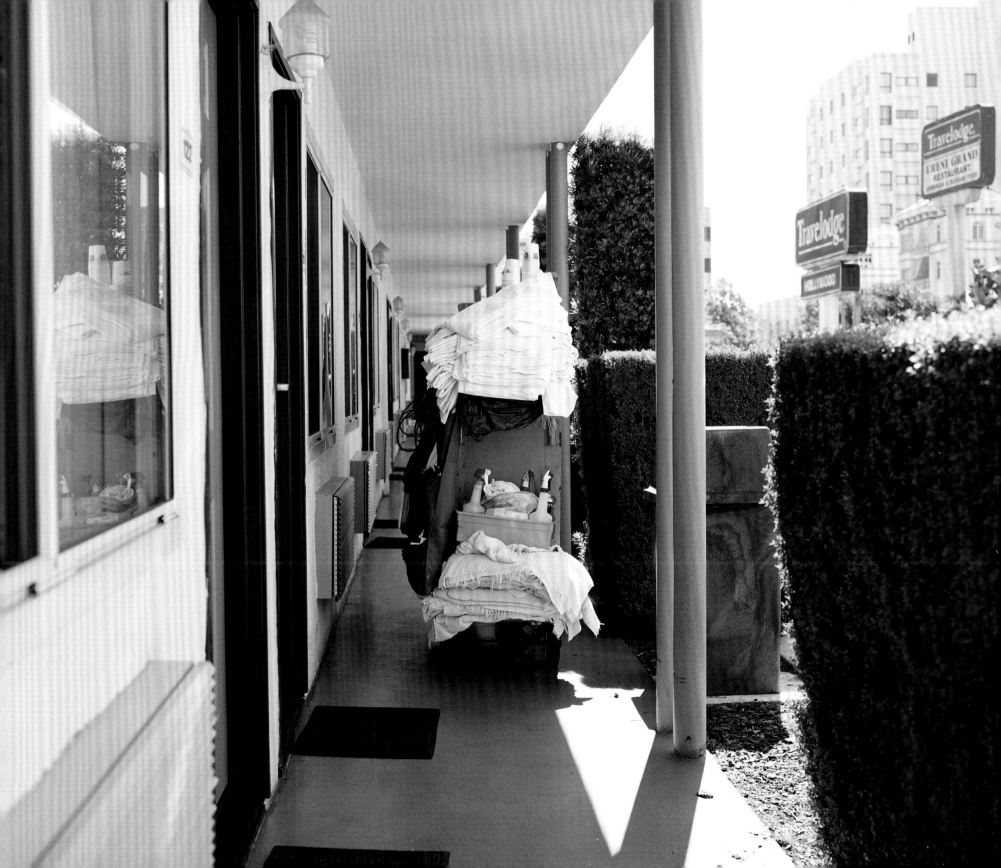

I, _____Walker Esner_____, can testify to observing and

being attendant for Chris Buck's "Presence" photo session

with _____THE LIARS_____. And can vouch for the

subject's being within the photographer's frame despite not

being visible.

Witness signature

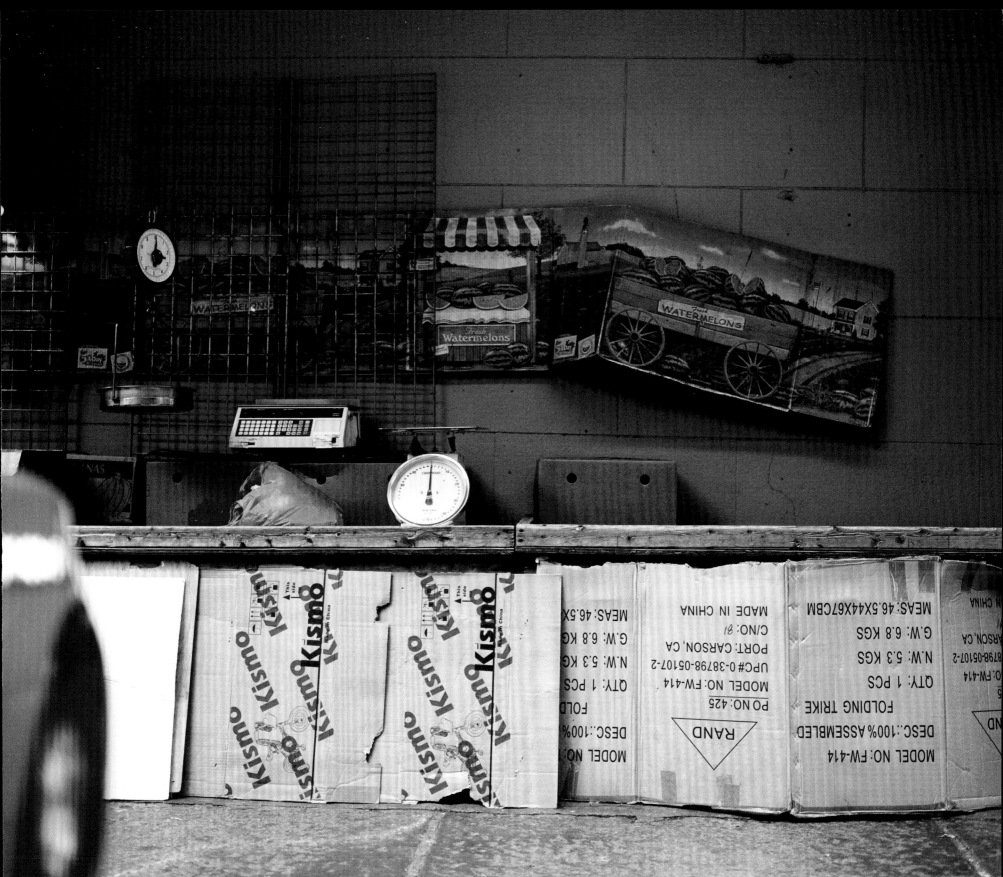

I, _____Hilary Villa_____, can testify to observing and

being attendant for Chris Buck's "Presence" photo session

with _____NICK CAVE_____. And can vouch for the

subject's being within the photographer's frame despite not

being visible.

_____Hilary Villa_____
Witness signature

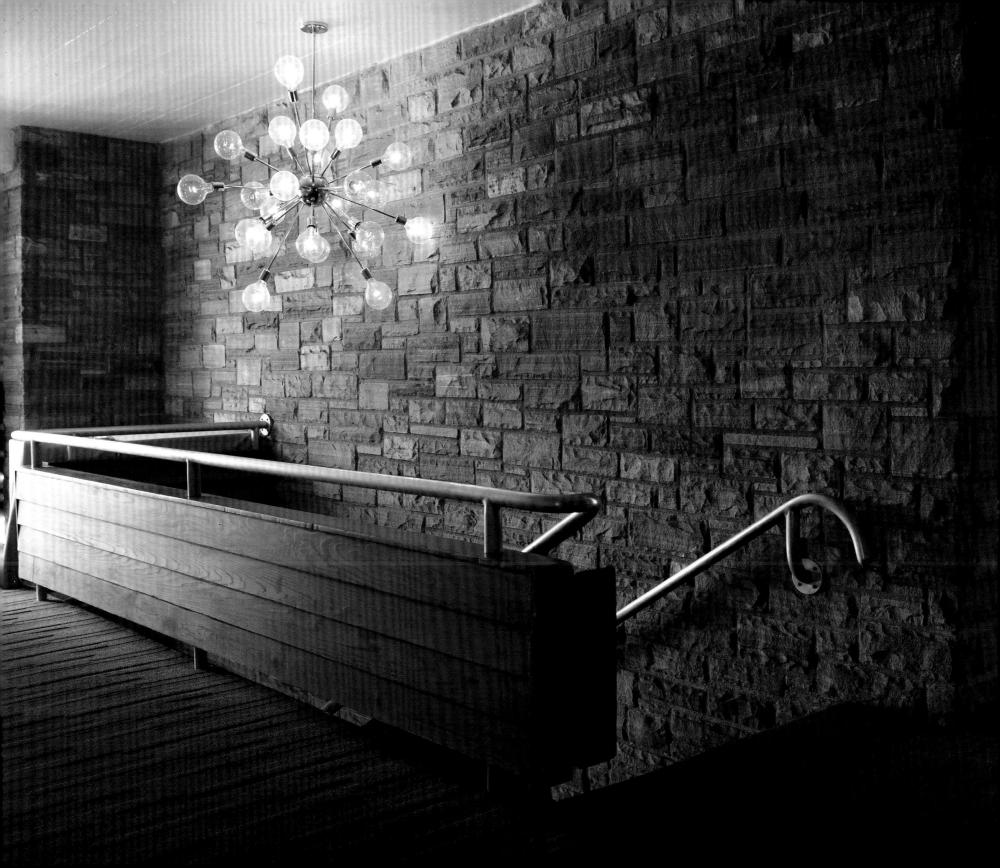

I, _____Angela Kohler_____, can testify to observing and

being attendant for Chris Buck's "Presence" photo session

with _____**GNARLS BARKLEY**_____. And can vouch for the

subject's being within the photographer's frame despite not

being visible.

Witness signature

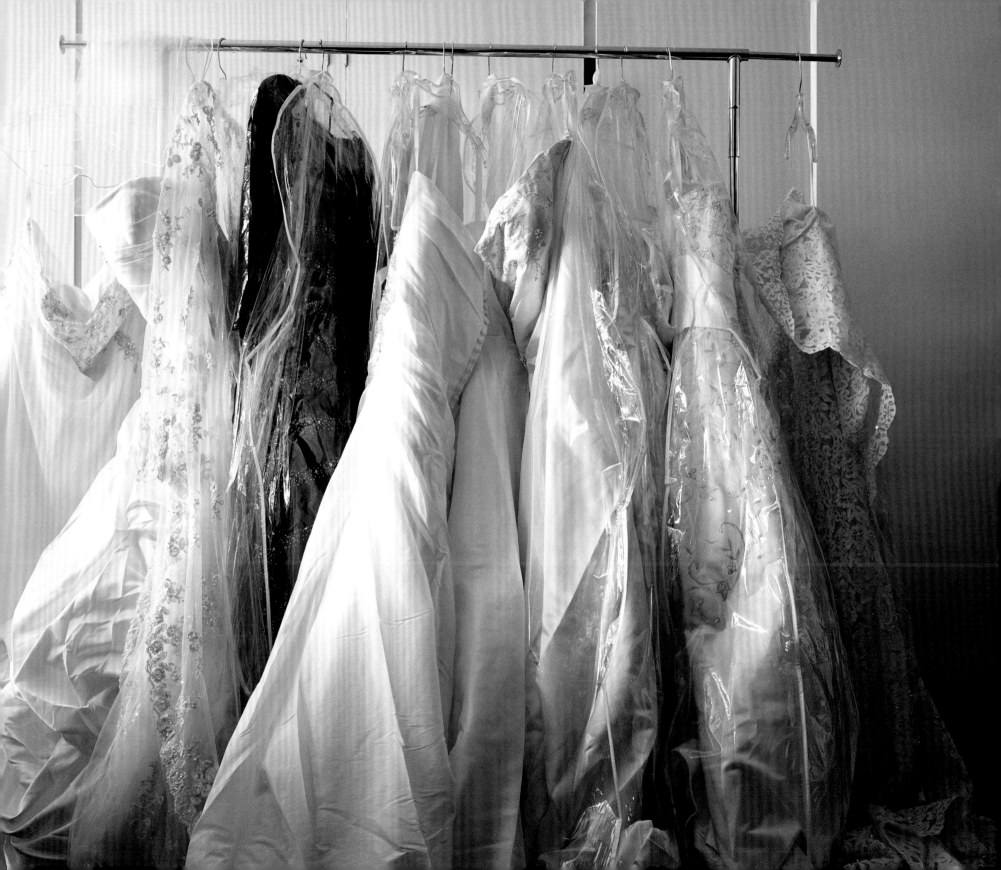

I, _____JOSH VAN PEAAL_____, can testify to observing and

being attendant for Chris Buck's "Presence" photo session

with _____RUSSELL BRAND_____. And can vouch for the

subject's being within the photographer's frame despite not

being visible.

Witness signature

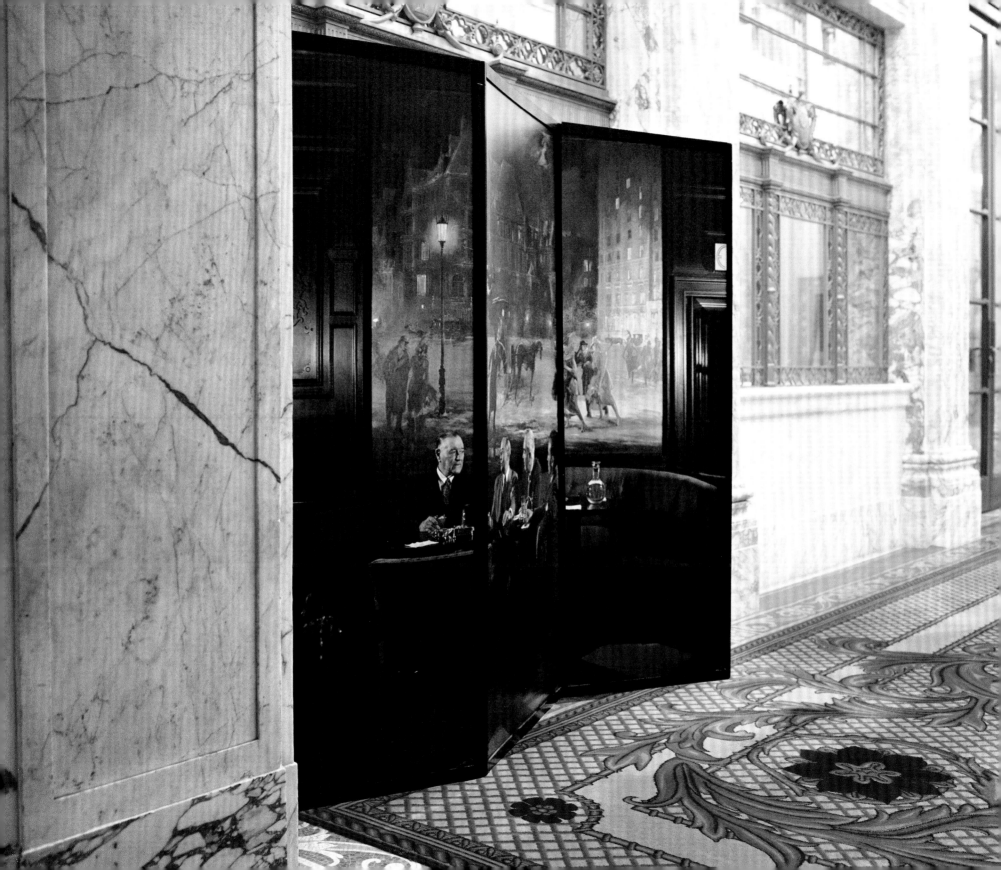

I, _____Angela Pierce_____, can testify to observing and

being attendant for Chris Buck's "Presence" photo session

with _____**JON HAMM**_____. And can vouch for the

subject's being within the photographer's frame despite not

being visible.

Witness signature

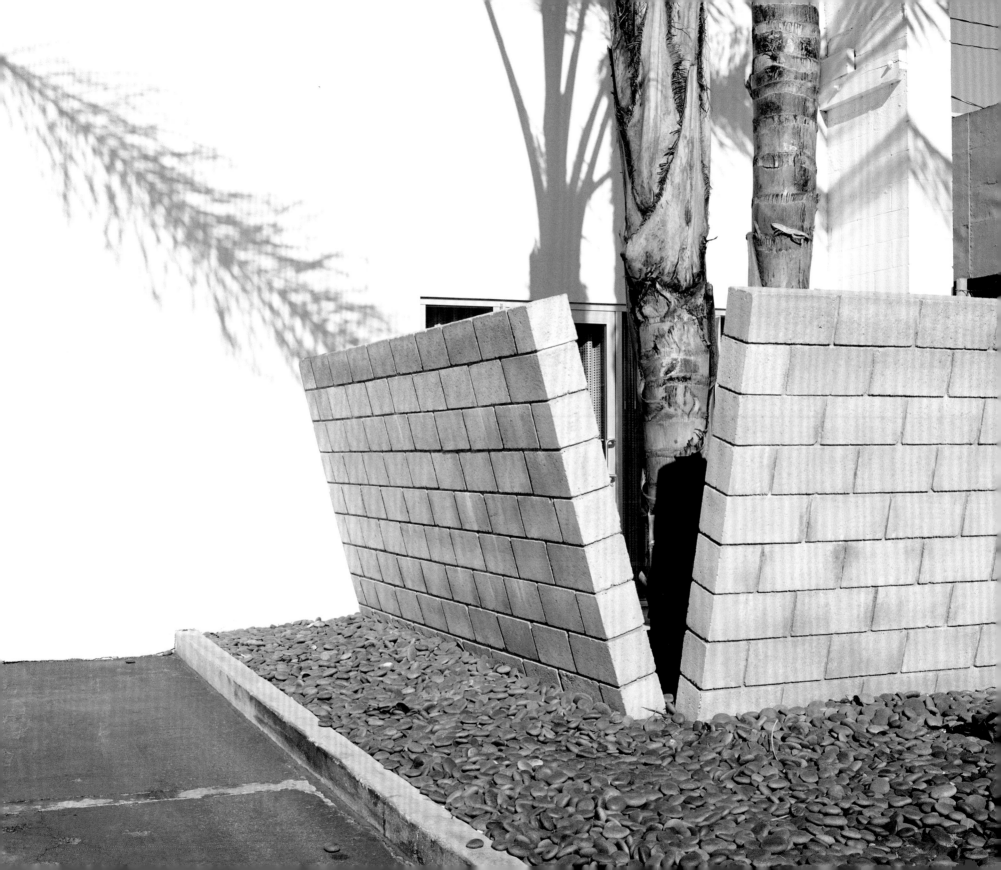

I, _____TARIK RICHARds_____, can testify to observing and

being attendant for Chris Buck's "Presence" photo session

with _____SNOOP DOGG_____. And can vouch for the

subject's being within the photographer's frame despite not

being visible.

Witness signature

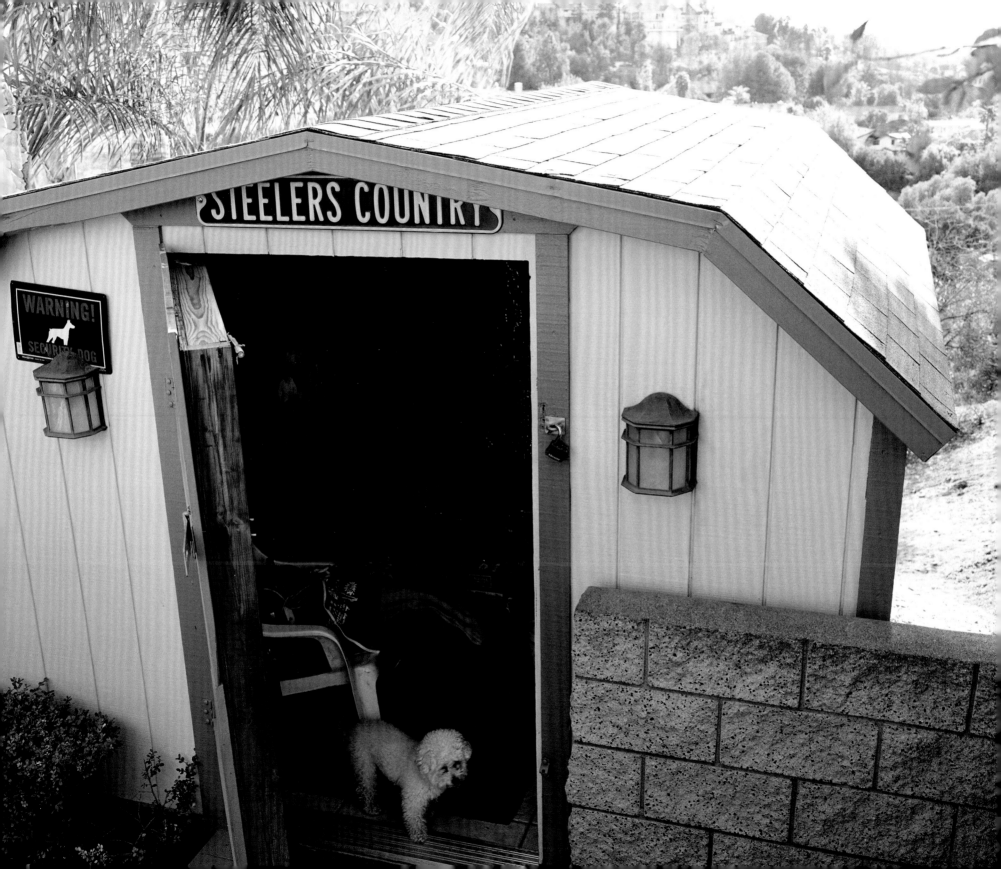

I, _____ MATT HOOVER _____, can testify to observing and

being attendant for Chris Buck's "Presence" photo session

with _____ NAS _____. And can vouch for the

subject's being within the photographer's frame despite not

being visible.

Witness signature

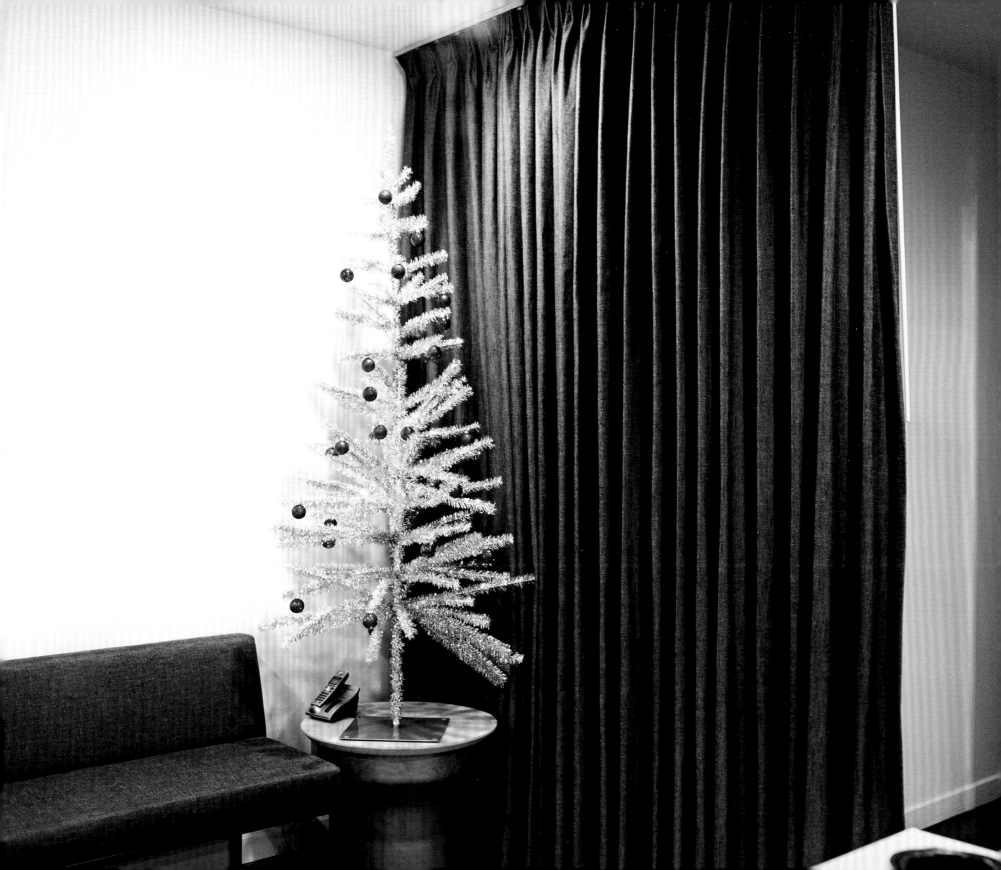

I, _____SUSAN AROSTEGUY_____, can testify to observing and

being attendant for Chris Buck's "Presence" photo session

with _____**MONTE HELLMAN**_____. And can vouch for the

subject's being within the photographer's frame despite not

being visible.

Witness signature

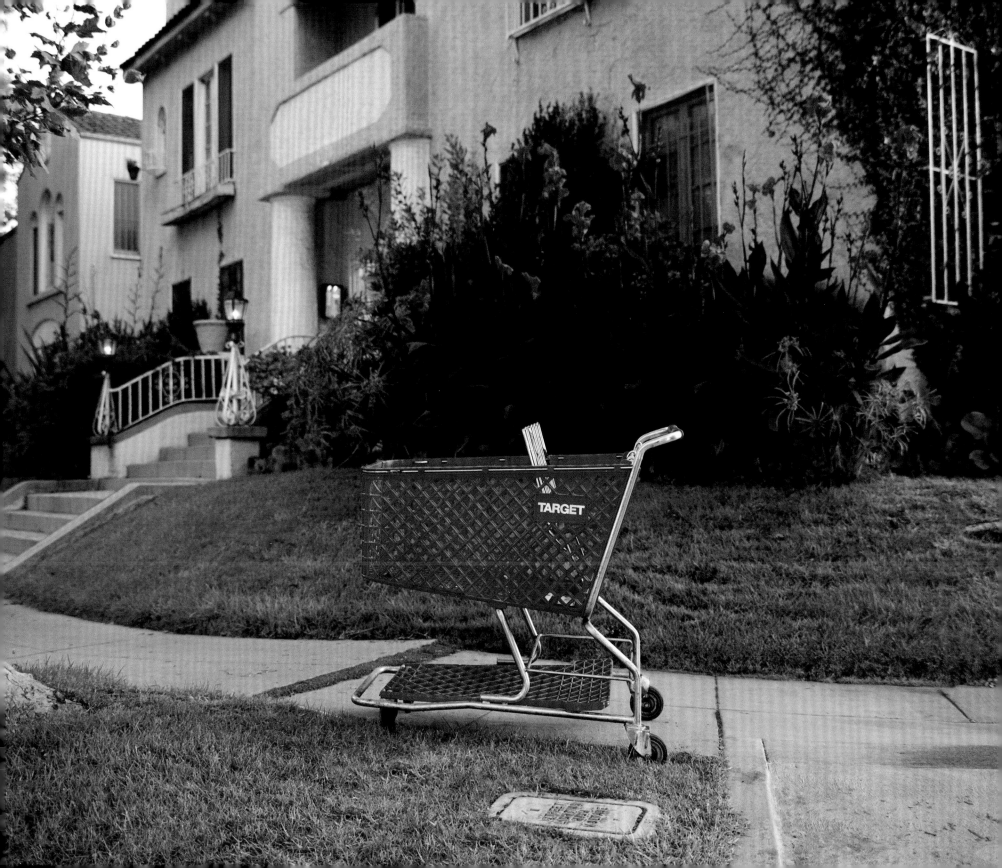

I, _____JOE TOMCHI_____, can testify to observing and

being attendant for Chris Buck's "Presence" photo session

with _____DUANE MICHALS_____. And can vouch for the

subject's being within the photographer's frame despite not

being visible.

Witness signature

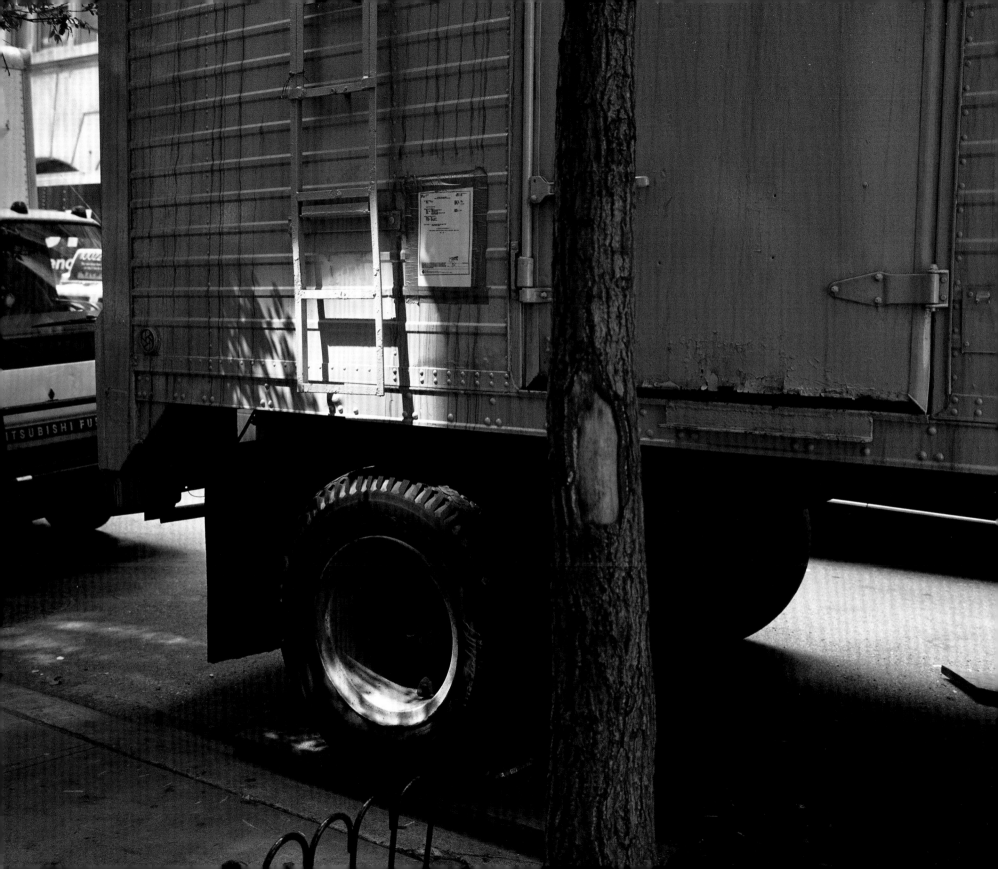

I, _____Angela Kohler_____, can testify to observing and

being attendant for Chris Buck's "Presence" photo session

with _____JUDD APATOW_____. And can vouch for the

subject's being within the photographer's frame despite not

being visible.

Witness signature

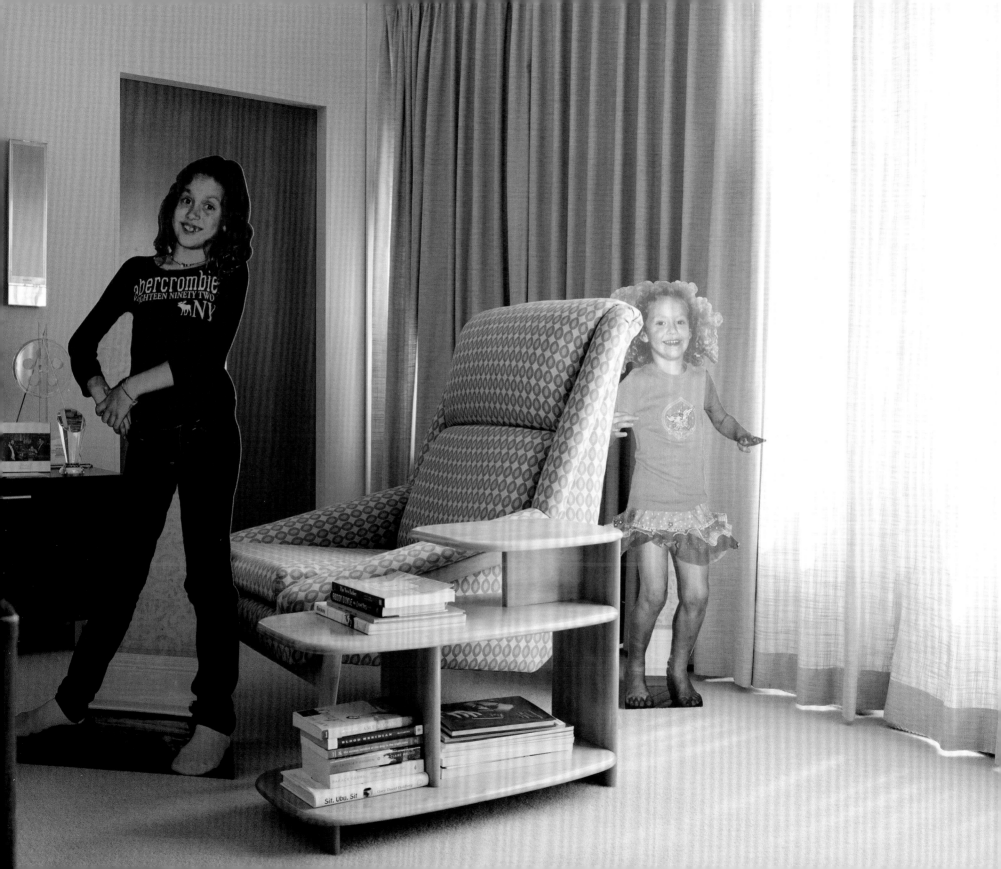

I, _____Michelle Golden_____, can testify to observing and

being attendant for Chris Buck's "Presence" photo session

with ___THE NEW PORNOGRAPHERS___. And can vouch for the

subject's being within the photographer's frame despite not

being visible.

Witness signature

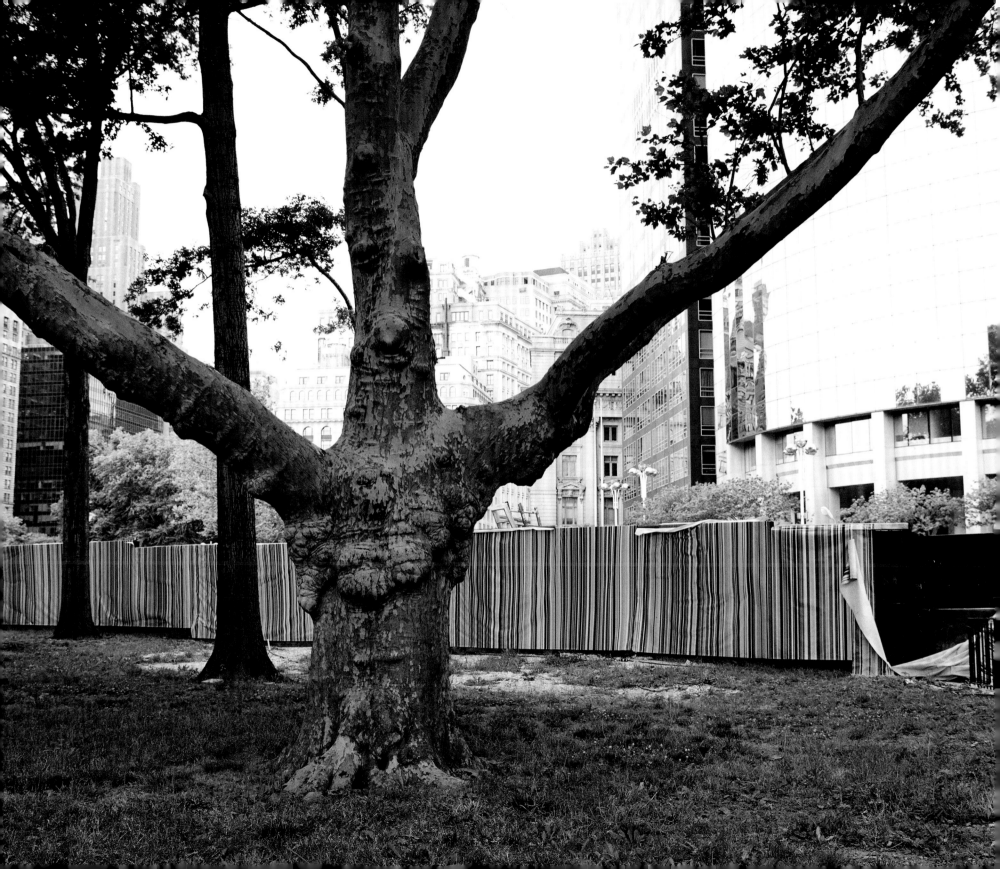

I, _____Dan Weiner_____, can testify to observing and

being attendant for Chris Buck's "Presence" photo session

with _____JACK BLACK_____. And can vouch for the

subject's being within the photographer's frame despite not

being visible.

Witness Signature

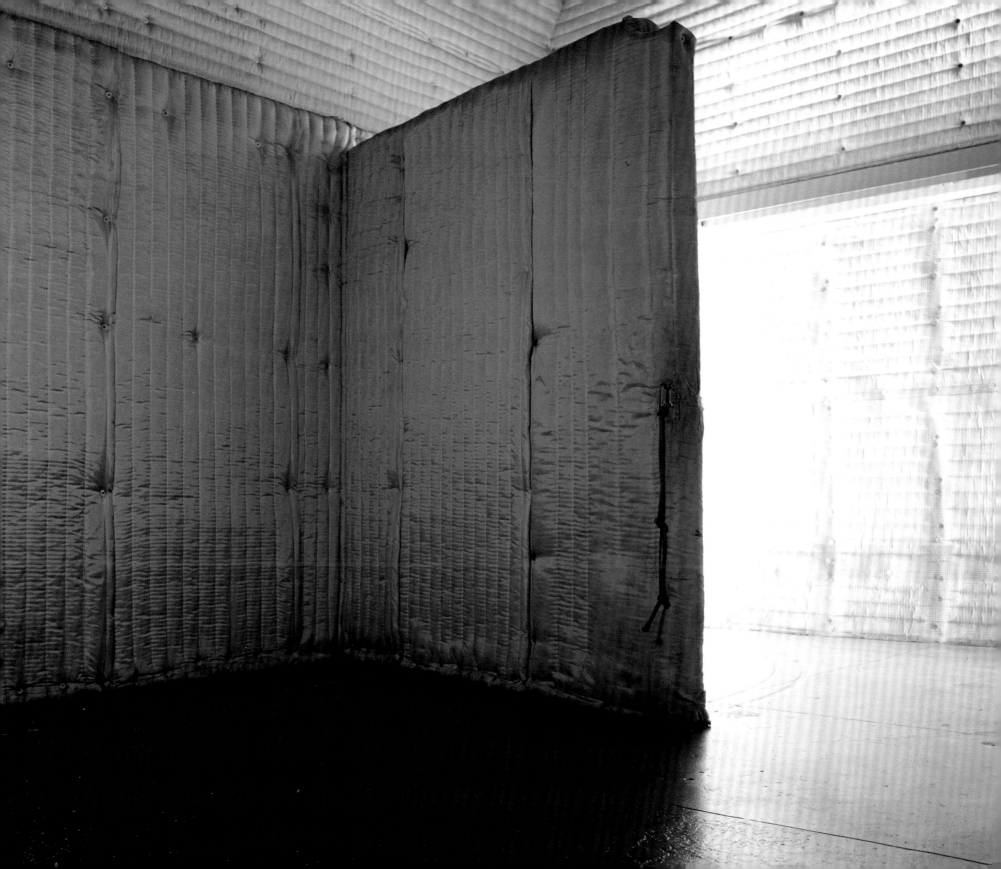

I, _____CHRISTINE BECKER_____, can testify to observing and

being attendant for Chris Buck's "Presence" photo session

with _____GÜNTER GRASS_____. And can vouch for the

subject's being within the photographer's frame despite not

being visible.

Christine Becker
<u>...</u>
Witness signature

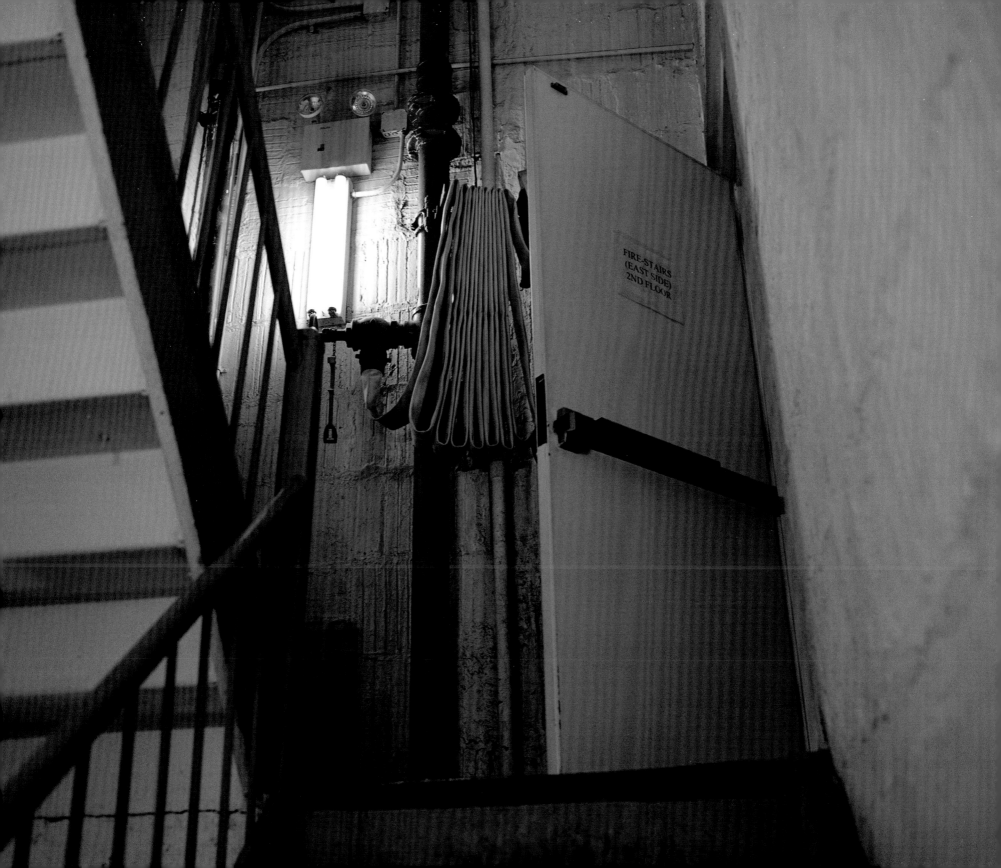

I, _____Caitlin Crews_____, can testify to observing and

being attendant for Chris Buck's "Presence" photo session

with _____THE FIERY FURNACES_____. And can vouch for the

subject's being within the photographer's frame despite not

being visible.

Witness signature

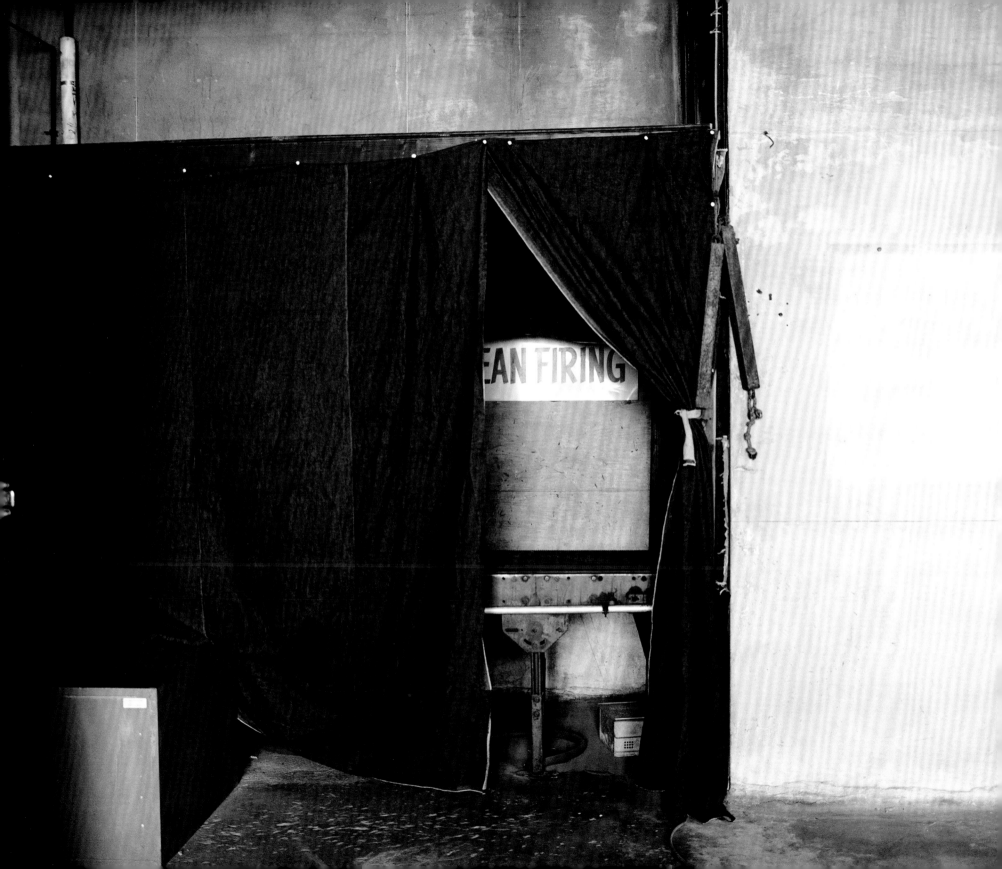

I, _____Emma Brockes_____, can testify to observing and

being attendant for Chris Buck's "Presence" photo session

with _____TINA BROWN_____. And can vouch for the

subject's being within the photographer's frame despite not

being visible.

Witness signature

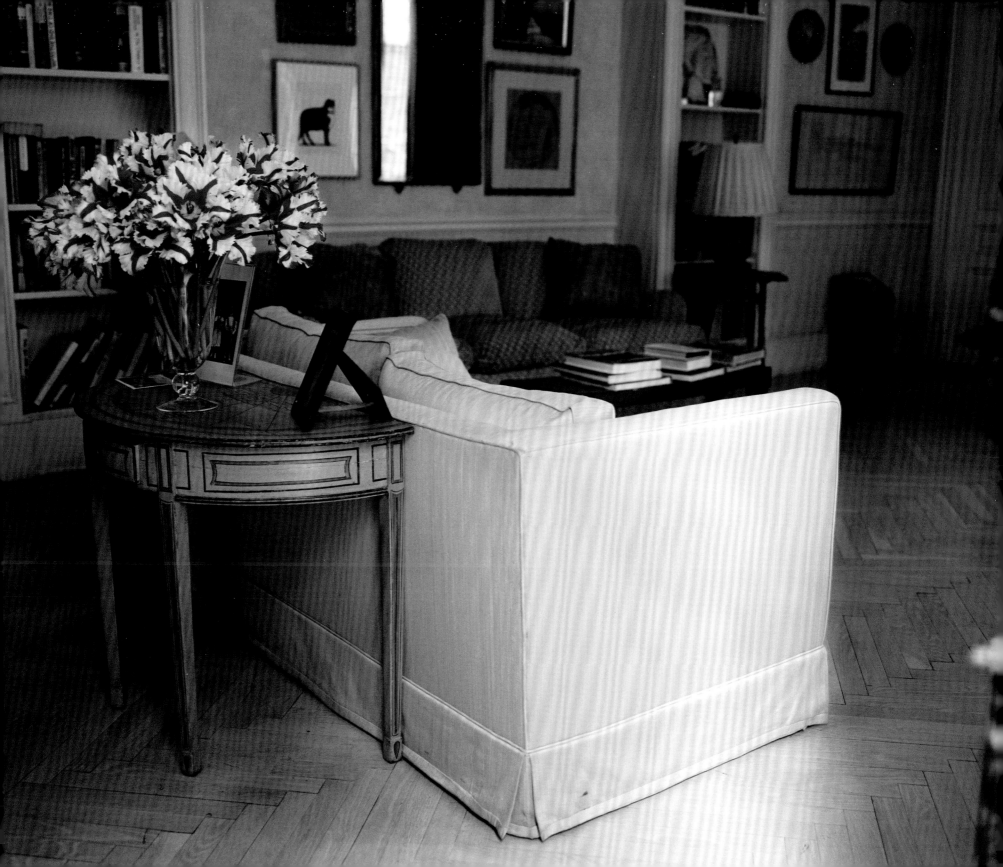

I, _____Josè Leòn_____, can testify to observing and

being attendant for Chris Buck's "Presence" photo session

with _____WES CRAVEN_____. And can vouch for the

subject's being within the photographer's frame despite not

being visible.

Witness signature

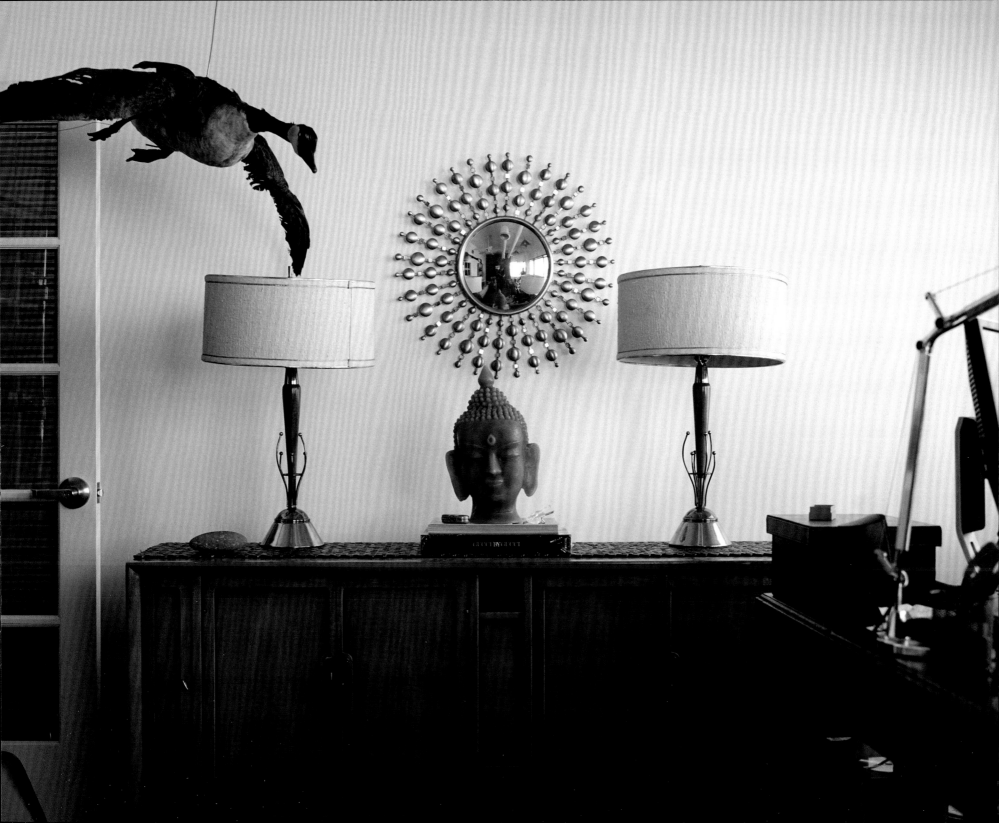

I, _____Aurélie Graillot_____, can testify to observing and

being attendant for Chris Buck's "Presence" photo session

with _____**STEVE COOGAN**_____. And can vouch for the

subject's being within the photographer's frame despite not

being visible.

Witness signature

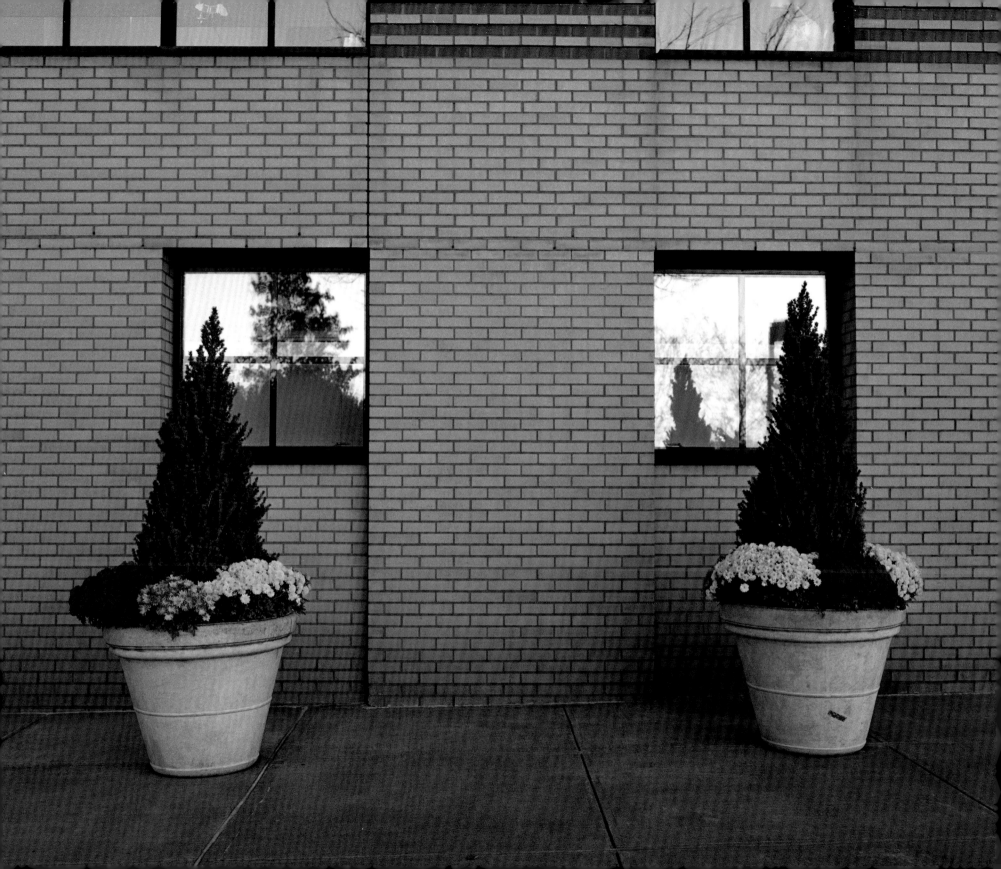

I, _____ LILIAS HAHN _____, can testify to observing and

being attendant for Chris Buck's "Presence" photo session

with _____ UWE BOLL _____. And can vouch for the

subject's being within the photographer's frame despite not

being visible.

Lilias Hahn
Witness signature

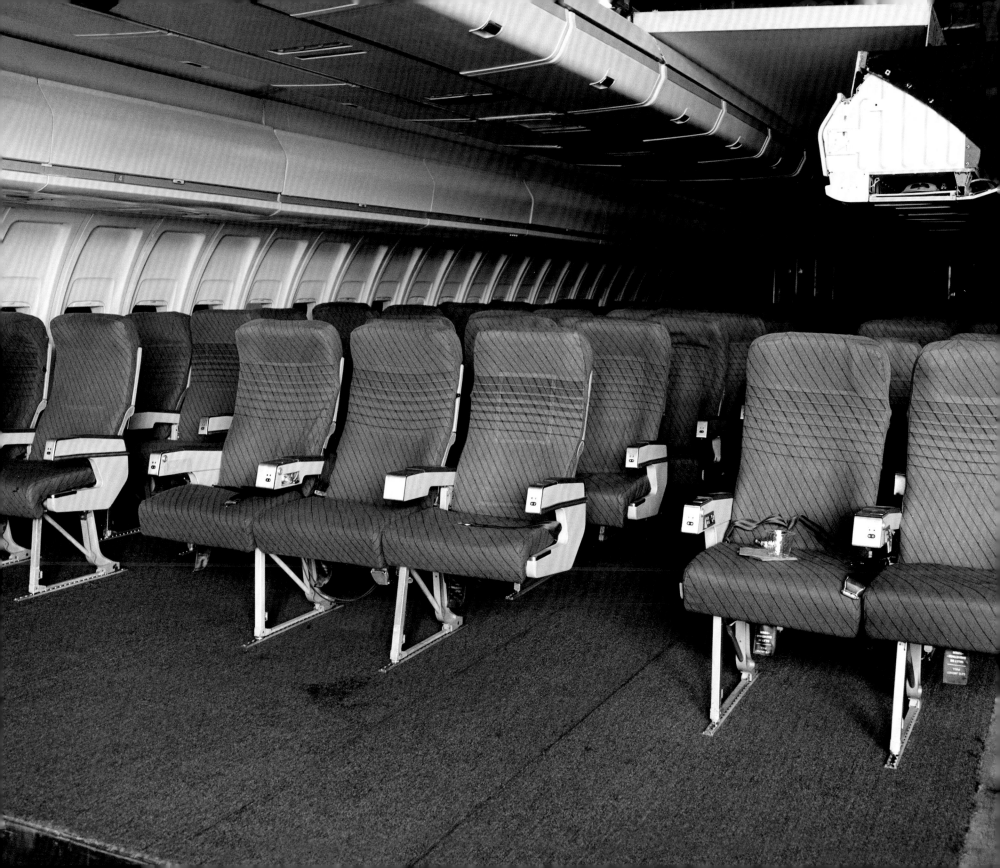

I, _____Matt Ginella_____, can testify to observing and

being attendant for Chris Buck's "Presence" photo session

with _____JACK NICKLAUS_____. And can vouch for the

subject's being within the photographer's frame despite not

being visible.

Witness signature

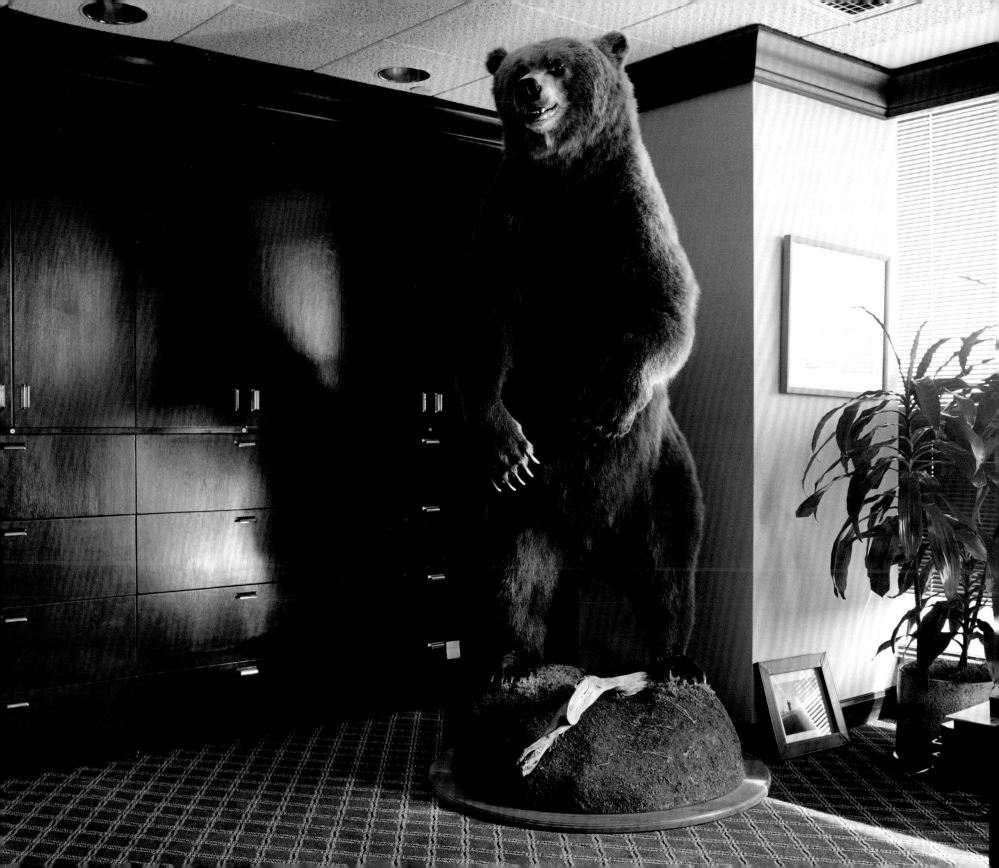

I, _____Nicole Chabot_____, can testify to observing and

being attendant for Chris Buck's "Presence" photo session

with _____RAINN WILSON_____. And can vouch for the

subject's being within the photographer's frame despite not

being visible.

Witness signature

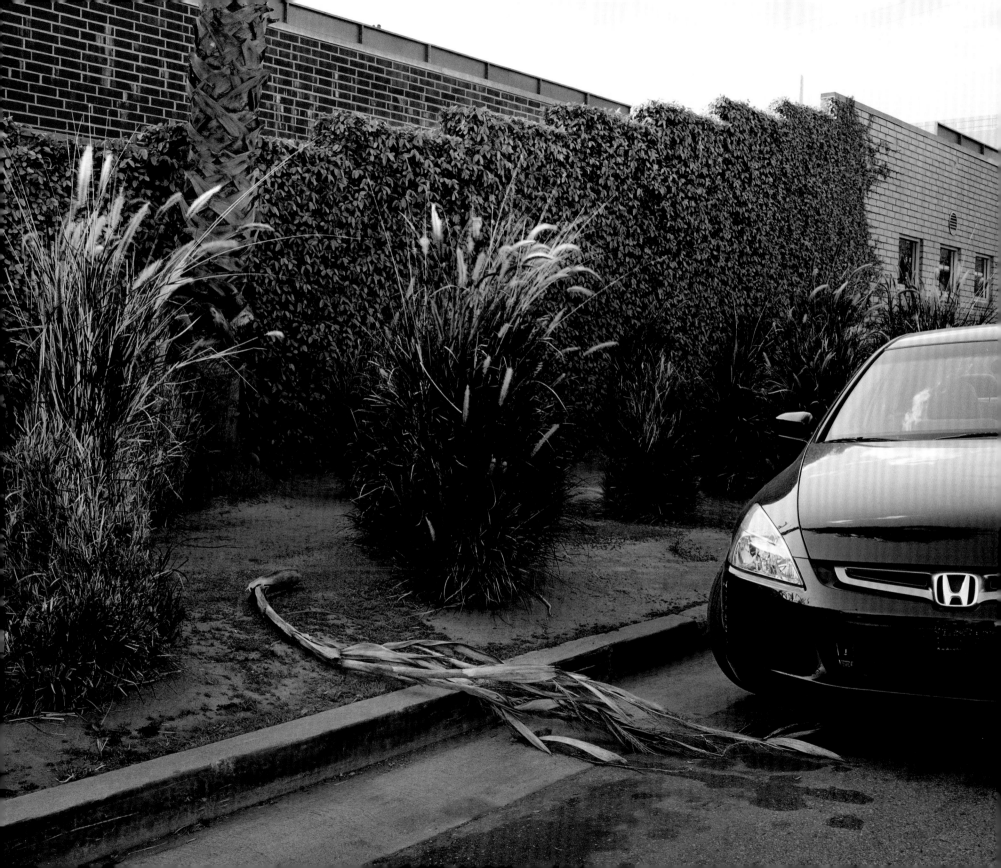

I, _____ Amy Zvi _____, can testify to observing and

being attendant for Chris Buck's "Presence" photo session

with _____ SARAH SILVERMAN _____. And can vouch for the

subject's being within the photographer's frame despite not

being visible.

Witness signature

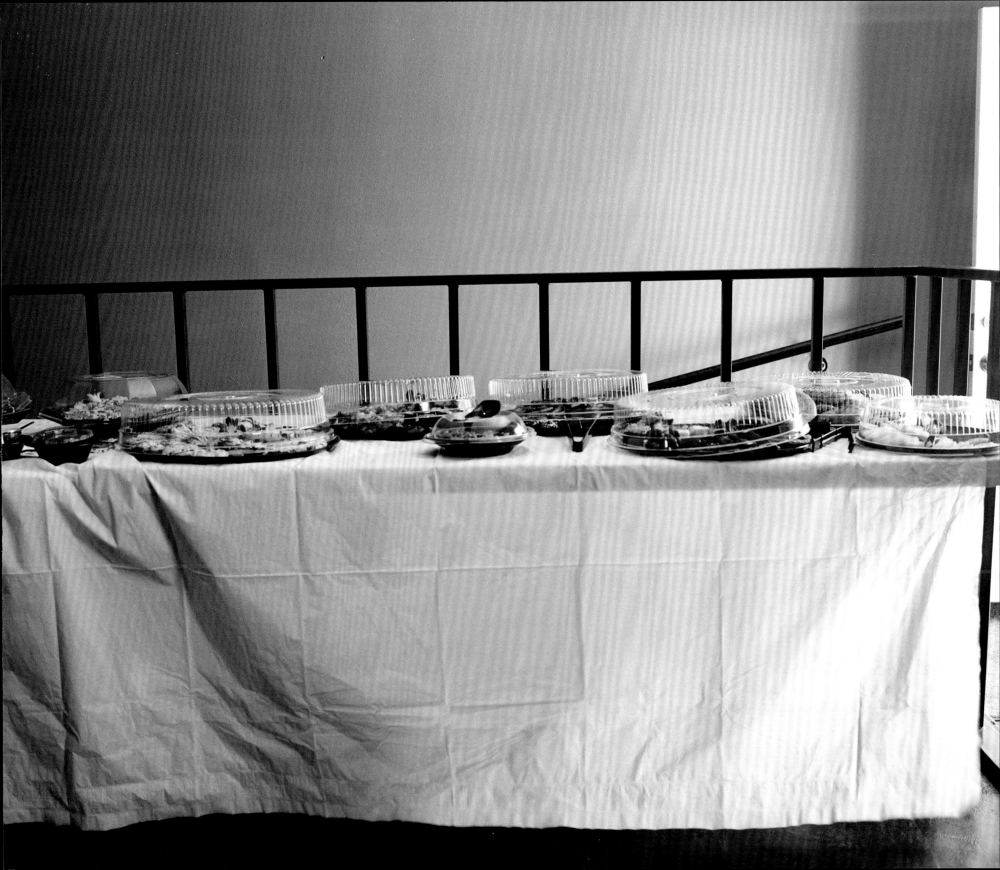

I, _____Paul Moakley_____, can testify to observing and

being attendant for Chris Buck's "Presence" photo session

with _____TRACEY ULLMAN_____. And can vouch for the

subject's being within the photographer's frame despite not

being visible.

Witness signature

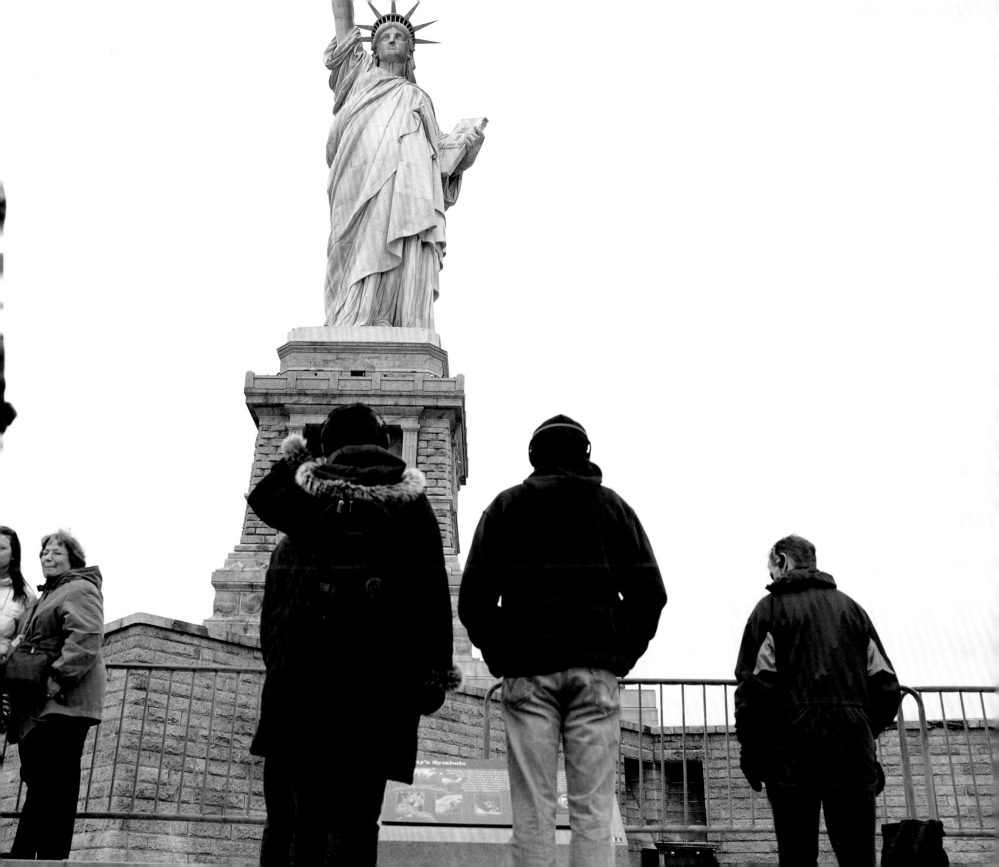

I, _____Michael Simons_____, can testify to observing and

being attendant for Chris Buck's "Presence" photo session

with _____ANDY SAMBERG_____. And can vouch for the

subject's being within the photographer's frame despite not

being visible.

Witness signature

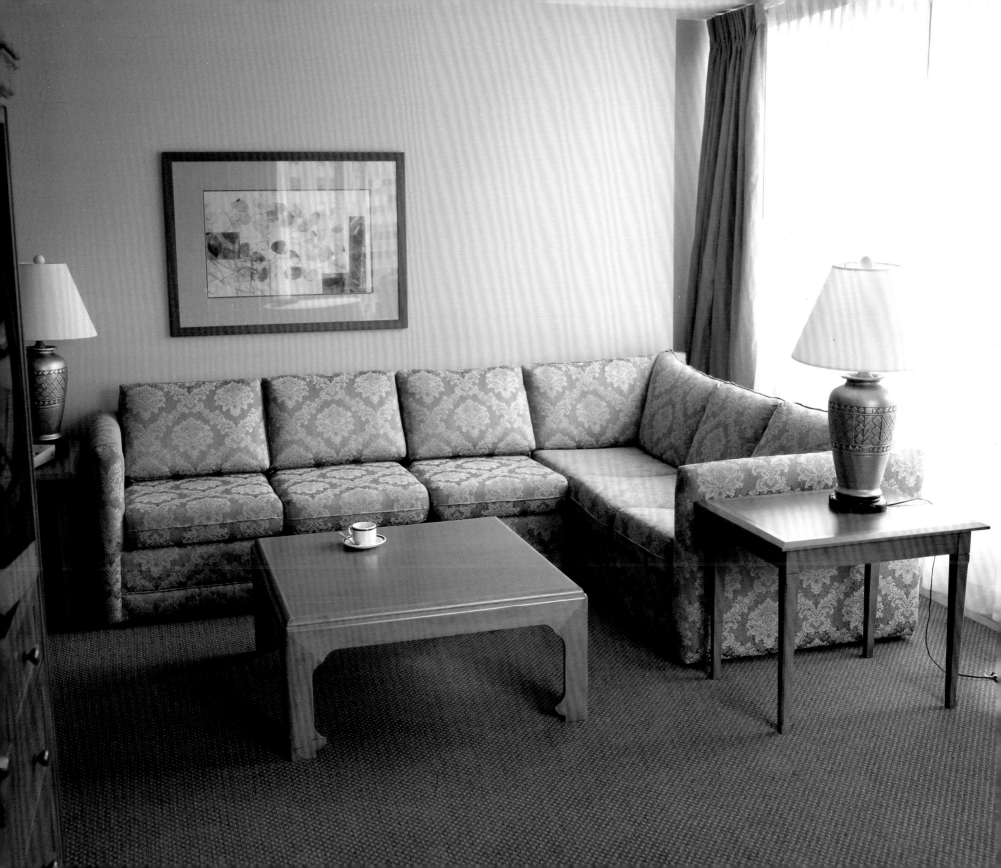

I, _____Miranda Dempster_____, can testify to observing and

being attendant for Chris Buck's "Presence" photo session

with _____MARC NEWSON_____. And can vouch for the

subject's being within the photographer's frame despite not

being visible.

M Dempt
Witness signature

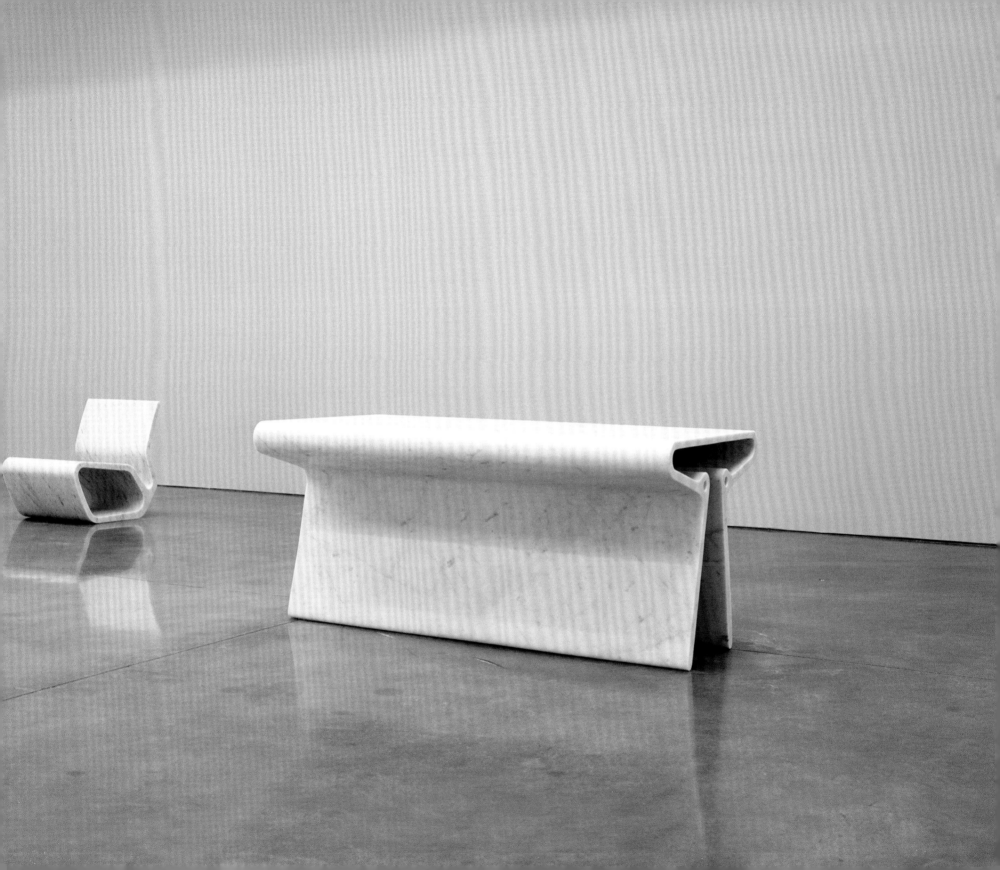

I, _____PHILIP RINALDI_____, can testify to observing and

being attendant for Chris Buck's "Presence" photo session

with _____PATTI LuPONE_____. And can vouch for the

subject's being within the photographer's frame despite not

being visible.

_____Philip Rinaldi_____
Witness signature

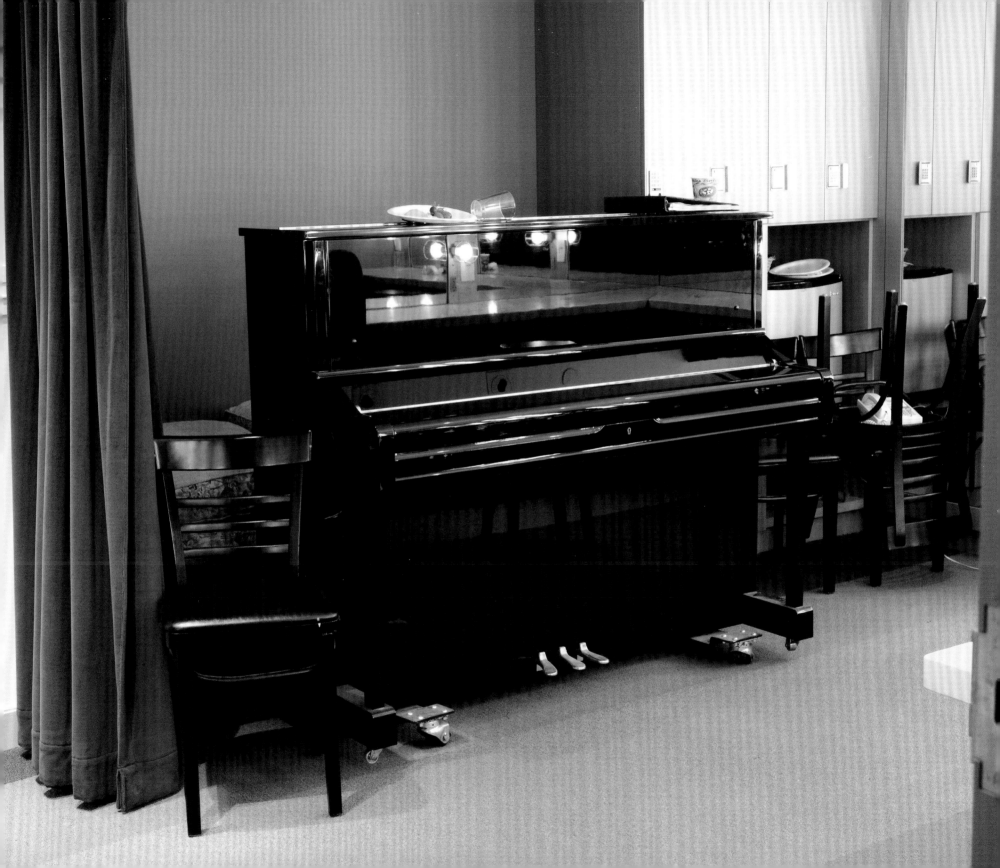

I, _____Mark Stone_____, can testify to observing and

being attendant for Chris Buck's "Presence" photo session

with __MASAHARU MORIMOTO__. And can vouch for the

subject's being within the photographer's frame despite not

being visible.

Witness signature

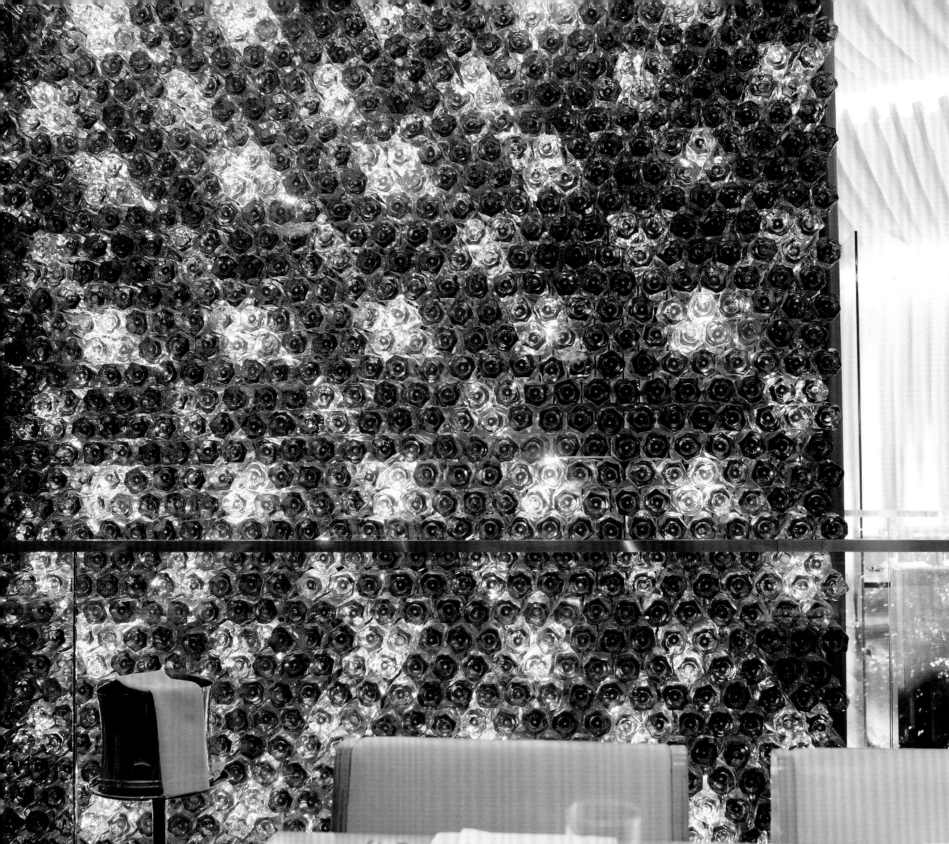

I, _____Angela Pierce_____, can testify to observing and

being attendant for Chris Buck's "Presence" photo session

with _____**TODD BRIDGES**_____. And can vouch for the

subject's being within the photographer's frame despite not

being visible.

Witness signature

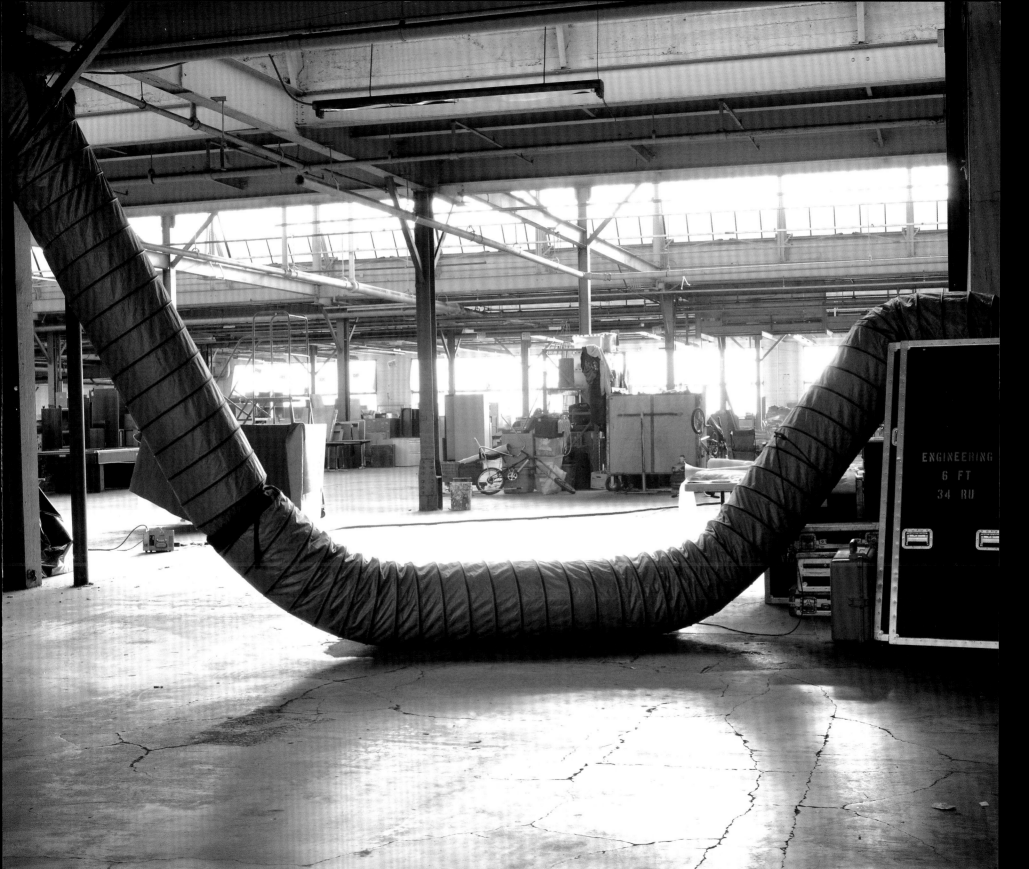

I, _DEVENDRA BANHART_, can testify to observing and

being attendant for Chris Buck's "Presence" photo session

with DEVENDRA BANHART. And can vouch for the

subject's being within the photographer's frame despite not

being visible.

Witness signature

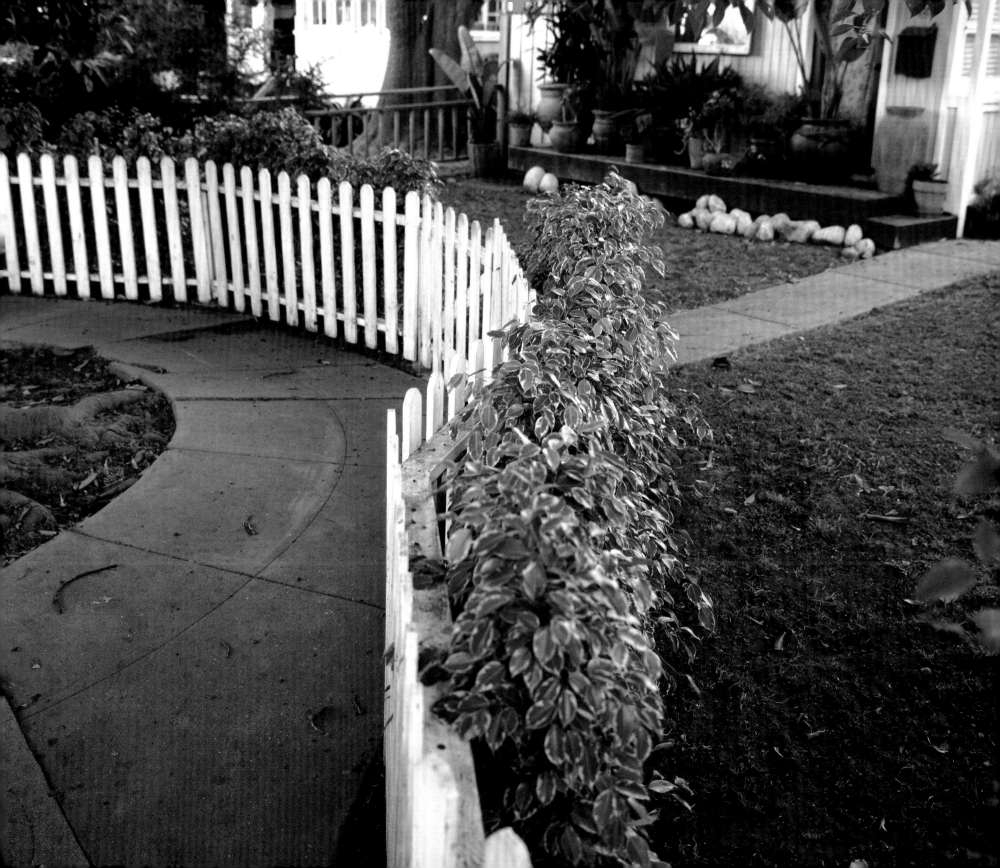

I, _____JESSE DAWSON_____, can testify to observing and

being attendant for Chris Buck's "Presence" photo session

with _____**WEIRD AL YANKOVIC**_____. And can vouch for the

subject's being within the photographer's frame despite not

being visible.

Witness signature

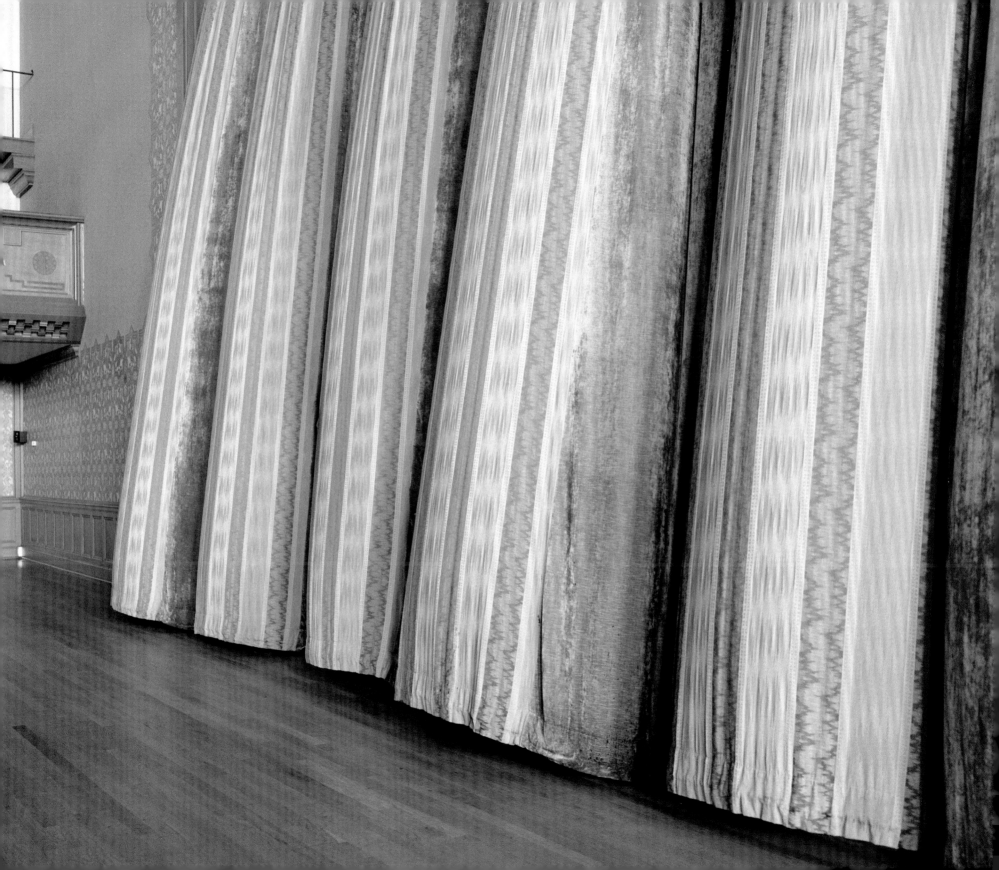

I, _____Whitney Tressel_____, can testify to observing and

being attendant for Chris Buck's "Presence" photo session

with _____CHEVY CHASE_____. And can vouch for the

subject's being within the photographer's frame despite not

being visible.

Witness signature

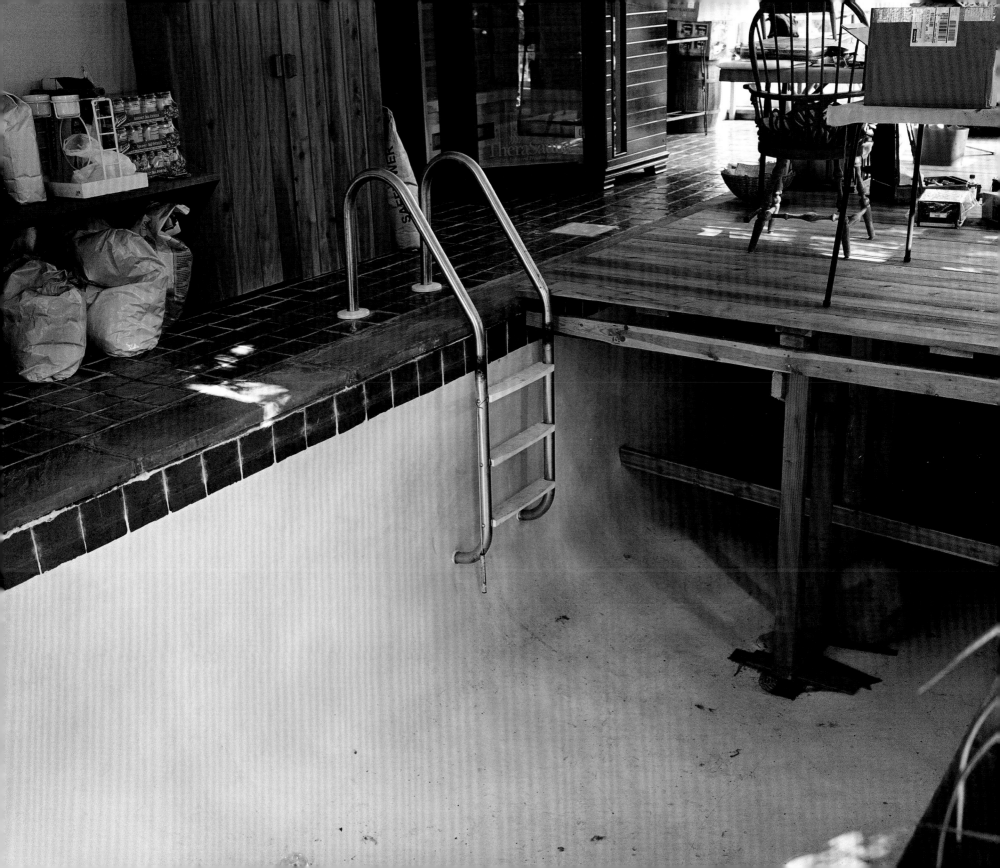

I, _____Marlene Romos_____, can testify to observing and

being attendant for Chris Buck's "Presence" photo session

with _____ROBERT DE NIRO_____. And can vouch for the

subject's being within the photographer's frame despite not

being visible.

Witness signature

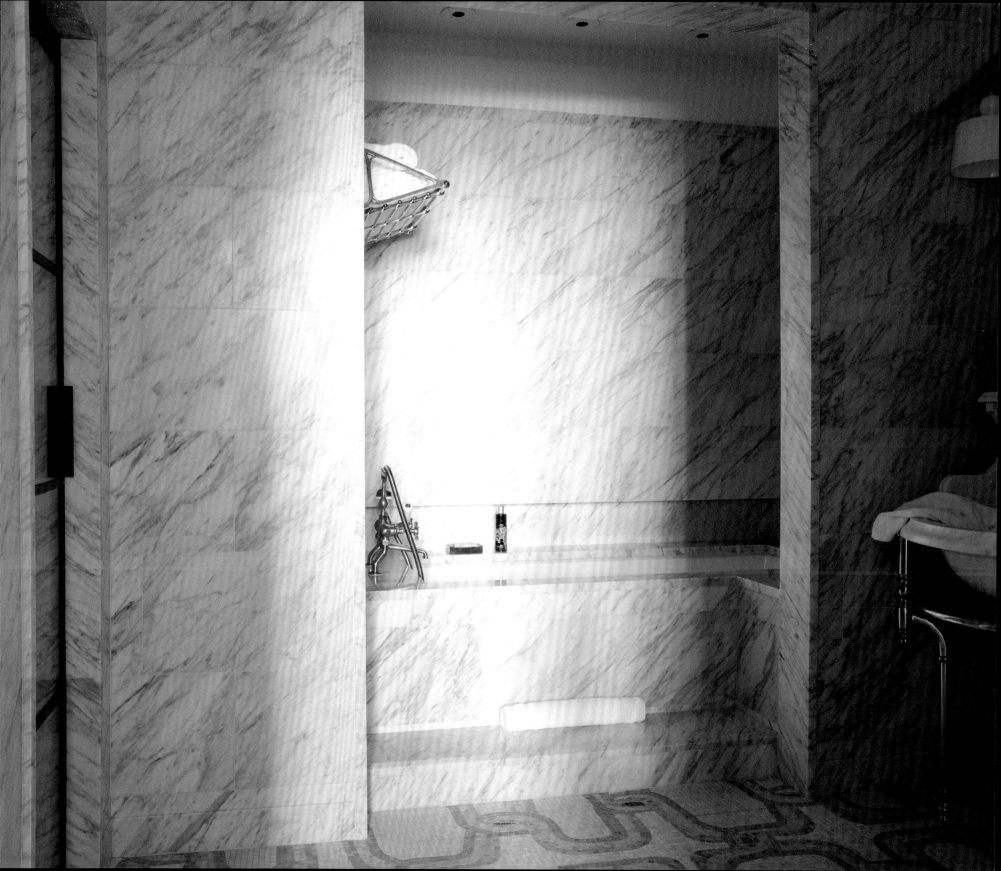

I, _____Amelia Tubb_____, can testify to observing and

being attendant for Chris Buck's "Presence" photo session

with _____RINGO STARR_____. And can vouch for the

subject's being within the photographer's frame despite not

being visible.

Witness signature

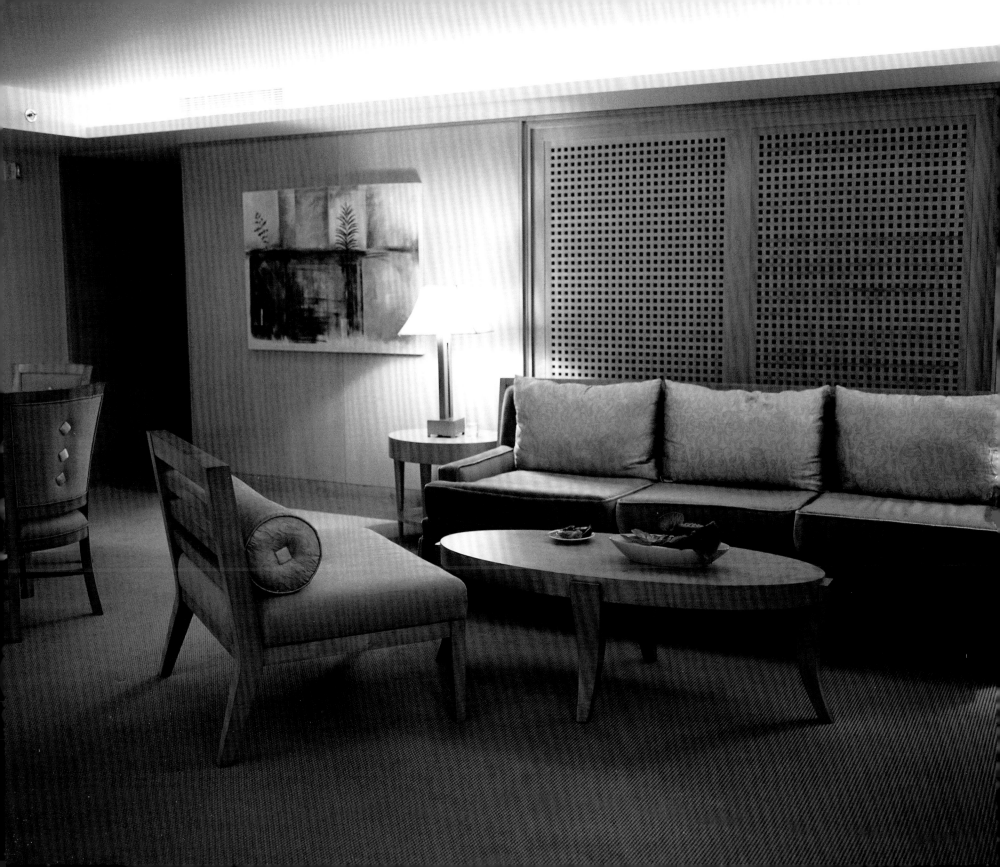

I, _____Tim Powis_____, can testify to observing and

being attendant for Chris Buck's "Presence" photo session

with _____JONATHAN FRANZEN_____. And can vouch for the

subject's being within the photographer's frame despite not

being visible.

Witness signature

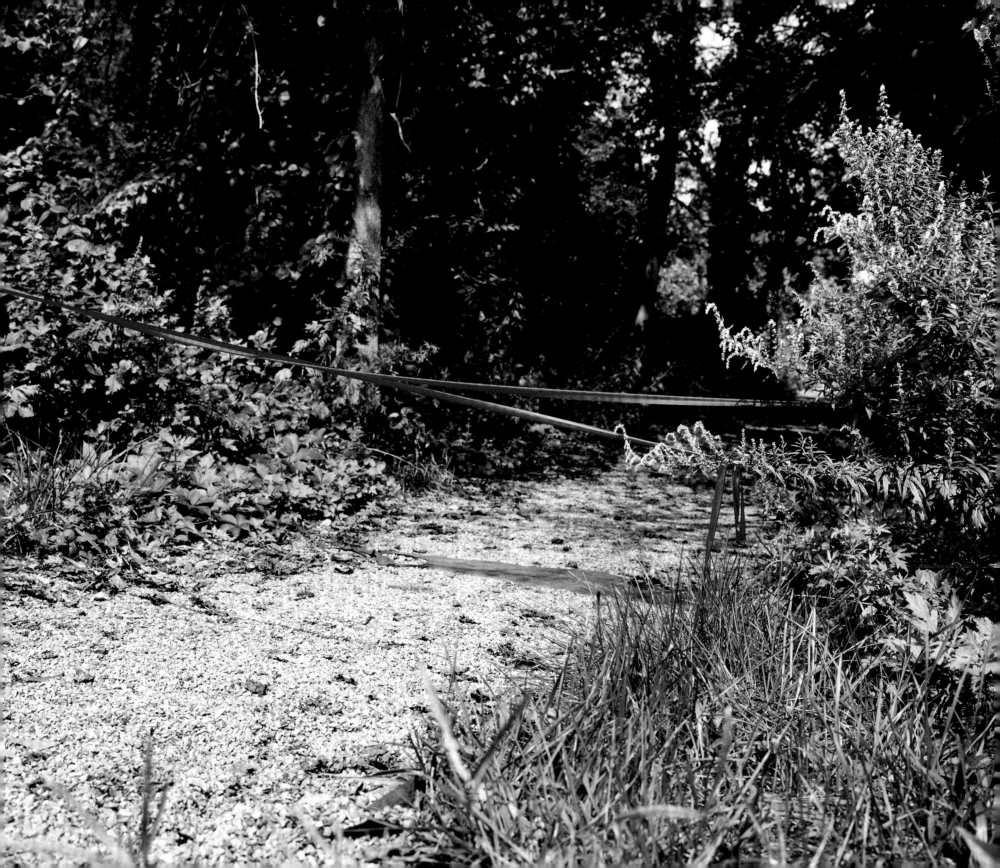

I, _____JOE TOMCHO_____, can testify to observing and

being attendant for Chris Buck's "Presence" photo session

with _____TRACY MORGAN_____. And can vouch for the

subject's being within the photographer's frame despite not

being visible.

Witness signature

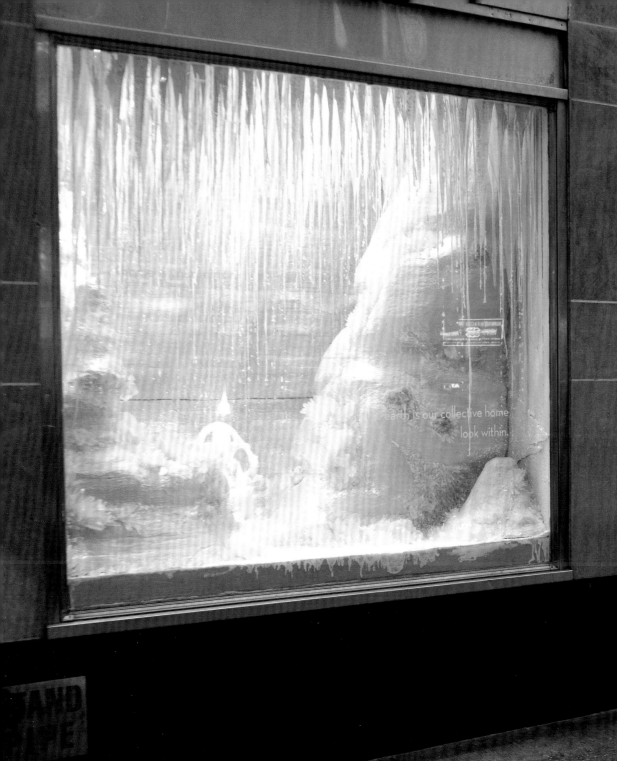

earth is our collective home
look within.

880
BROADWAY

I, _____ Sherri O'Connor _____, can testify to observing and

being attendant for Chris Buck's "Presence" photo session

with ___ARCHBISHOP DESMOND TUTU___. And can vouch for the

subject's being within the photographer's frame despite not

being visible.

Sherri O'Connor
Witness signature

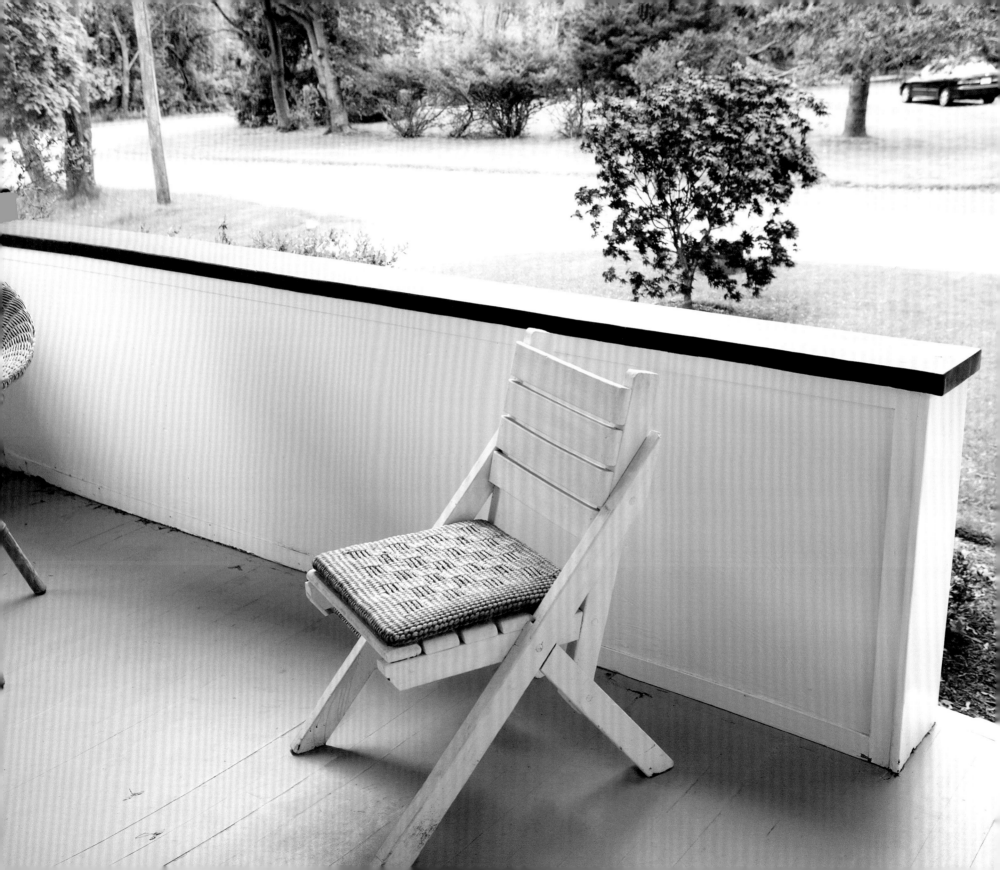

NOTES AND ACKNOWLEDGMENTS

This is a collection of celebrity portraits. Each is titled with the sitter's name as the subjects are physically within the frame; hiding behind or under some feature in the photograph.

The sessions generally followed a predictable course: I, or on occasion the subject, chose a location. The subject entered in such a way that his or her entire body was concealed. I'd shoot a dozen or so frames and then subjects would emerge from their hiding place.

The results are portraits in which the famous sitters are present but invisible. The varying circumstances offer up a range of hiding places; It could be a couch, a doorway, a bush, or a car, but whatever it is, it has to hide a full-grown adult.

Displayed across from each plate is a statement signed by a witness from the set, verifying that each sitting took place, and that the celebrity subject was actively participating. Witnesses were culled from those one would expect to find on a professional photo set, including photo assistants, wardrobe and prop stylists, editorial photo editors, public relations representatives, and friends of the subjects. In a handful of cases the subjects were asked to sign, as there was no one else present.

This constitutes the central methodology of *Presence*. The subjects are never digitally removed from the images.

Thank you to all of the subjects for their patience and willingness with this admittedly unorthodox project, especially Jonathan Franzen, Chuck Close, Michael Stipe, Monte Hellman, Russell Brand, The New Pornographers, Dave Matthews, Duane Michals, Devendra Banhart, and Cindy Sherman, who went out of their way to make time in their calendars for their sittings. I also want to acknowledge all of the witnesses whose signatures validated this project; Angela Kohler and Joe Tomcho in particular were present and helpful for many of the shoots. There are a number of folks who sat for *Presence* but whose portraits are not included in the final version. I appreciate their time and energy (in particular that of Judith Joy Ross).

Many people were supportive of this project in numerous ways. In project conceptualization, these people were great contributors: Julian Richards, Dhruv Chanchani, and Dakota Smith. Some people were simply morale-boosting, with the right word of advice or an attempt to connect me with a potential subject, including John Keatley, Mimi Cabell, Tika Buchanan, Ryan Roberts, and Megan McElwain.

There are some people whose contributions led directly to sittings; for that I am very, very grateful. Susan Arosteguy (Monte Hellman), Rodney Rothman (Russell Brand), Brett Radin (Dave Matthews), Nils Bernstein (The New Pornographers), Irene Papanestor (Chuck Close), and Tim Powis (Jonathan Franzen) truly delivered.

Presence enjoyed support from a lot of people over a long period of time, many of whom furnished invaluable introductions in finding a publisher and exhibition space: Doug Beube, Amy Stein, Kelli McLaughlin, Eric Ogden, Alex Prager, David Strettell, Freyda Tavin, Christopher Henry, Meg Handler, Reuel Golden, Michael Lavine, Rob Haggart, Douglas Levere, Reid Callanan, Darius Himes, and Mary Virginia Swanson were all instrumental in helping *Presence* find its place.

I received advice and direction from some top photography, art, and literary world presences, including Sara Rosen, Eric Miles, Maureen Huskey, Alison Elizabeth Taylor, Holly Hughes, Brian Wallis, Dave Heath, Greg Miller, Stella Kramer, Sheila Heti, and Bill Diodato. Thank you so much.

Many people went above and beyond the course of their professional roles in making the shoots happen. As this was a personal project for me, I do feel indebted to the following people. Top publicists: Whitney Tancred, Nicole Chabot, Matt Labov, Daniel Weiner, and Hilary Villa; photo editors and art directors: Kate Edwards, Caroline Hunter, Dora Somosi, Krista Prestek, Justin O'Neill, Amy Feitelberg, Rory Walsh, Amelia Tubb, Mary-Clancey Pace, Carrie Smith, Zana Woods, Kim Hubbard, Michael Norseng, Alison Unterreiner, Whitney Tressel, Jody Quon, Leana Alagia, Lea Golis, Reanna Evoy, David Lee, Cory Jacobs, Emily Crawford, Justin Solitrin, Miranda Dempster, Matt Ginella, Kimberly Merritt, Laurie Henzel, Nicole Flores, Adreinne Waheed, Michael Kochman, Audrey Landreth, and Paul Moakley; and other industry colleagues who lent their great talents help make these sessions happen: James Mahon, Matt Hoover, Sarah Wilmer, Fi Campbell-Johnson, Marisa Bernard, Michelle Chu, Walker Esner, Suzi Sadler, Jesse Dawson, and Yael Young.

My team of day-to-day personal and professional partners deserve a pointed thanks: especially my U.S. agents, Patrick Casey and Amanda Steinberger; my Canadian agent, Jooli Kim; my webmaster, Lucas Mulder; my forever loyal parents, George and Margo Buck; and my wonderful wife, Michelle Golden.

Special thank-yous go to others who actually built the book with me, without whom this book simply would not exist: Stephen Gates, who contributed so much to the feel and scope of the project, not least the design of the book; Alan Rapp, who represented the book in finding a publisher and provided sound advice in all aspects of completing *Presence*; Rodney Rothman, who wrote the Foreword; Nicole Lane Fulmer, who was involved in the early stages of making this project into a book; the photo labs Primary (who made most of the high-res scans) and Picturehouse (creating the final match prints—Claudia Galindo and B.J. DeLorenzo made CMYK magic); Andrew Hetherington, who interviewed me for an early mock-up; Deborah Birkett, who provided copy editing guidance; Brian Huskey, who was a contributing writer; and Alexa Becker and the fabulous creative team of Kehrer Verlag, who made me very happy by acquiring the project and then obsessing over every detail to bring it to completion as a book.

DATE DUE